IMAGES of America
PARK FOREST
DREAMS AND CHALLENGES

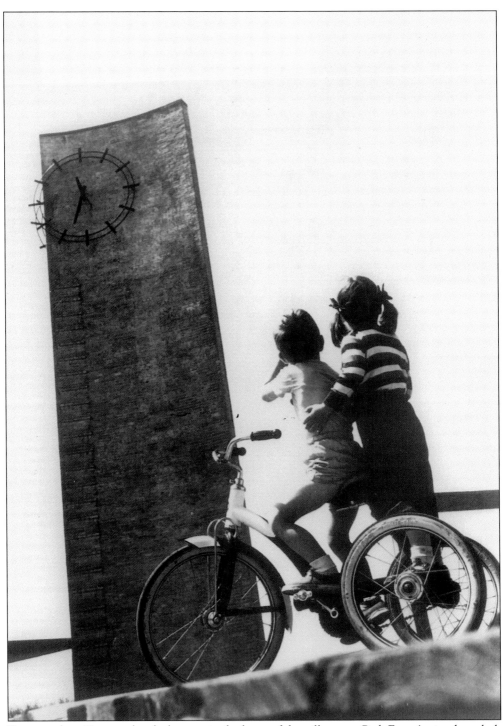
For more than 40 years, the clock tower in the heart of the village was Park Forest's visual symbol.

To Sharon Moll Melton
Park Forest Forever!

IMAGES of America
PARK FOREST
DREAMS AND CHALLENGES

Jerry Shnay

Copyright © 2002 by Jerry Shnay.
ISBN 978-0-7385-1950-0

Published by Arcadia Publishing
Charleston, South Csrolina

Printed in the United States of America

Library of Congress Catalog Card Number: 2001098709

For all general information contact Arcadia Publishing at:
Telephone 843-853-2070
Fax 843-853-0044
E-mail sales@arcadiapublishing.com
For customer service and orders:
Toll-Free 1-888-313-2665

Visit us on the Internet at www.arcadiapublishing.com

This book is dedicated to the people of Park Forest.

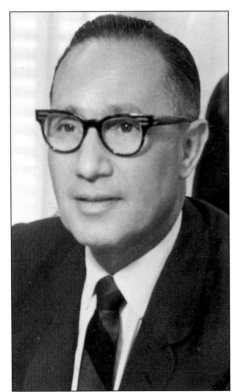

Philip Klutznick 1907–1999

Federal Public Housing Authority Commissioner
Secretary of Commerce
President B'nai B'rith International
President World Jewish Congress
Envoy to the United Nations
Builder, Developer, Philanthropist
Citizen of Park Forest

Contents

Acknowledgments 6

Introduction 7

1. Dreams in the Tent 9

2. Growth 19

3. A Photo Album 43

4. Challenges and Response 79

5. Celebrations 91

6. Then and Now 105

7. Capturing the Spirit 115

ACKNOWLEDGMENTS

No list of acknowledgements can begin without mentioning the efforts of Jane Nicoll, a reference librarian for the Park Forest Public Library and the devoted "keeper of the flame" for Park Forest's history as archivist for the Park Forest Historical Society. Jane has charge of the massive local history collection in the library. That collection includes more than 80 oral histories of Park Forest pioneers. Currently, a portion of that collection is being transferred to the library's website (www.pfpl.org) and is available to anyone interested in Park Forest's incredible history.

Thanks also go to Village Manager Janet Muchnik, Star Publications reporter Heather Pavnicka, Bob Smart, the Leonard Hetke family, Judy Lohr, the Goodrich clan, Amy Hensold (the historian for Faith United Protestant Church), Gayle Weil of B'nai Yehuda Beth Sholom, Mignon McDade, and to those not specifically mentioned who cajoled, advised, and encouraged the writer.

Approximately half the photographs in this book were selected from the thousands of images donated to the local history archives by both professional and amateurs. Special mention should be made of the work of Warren Skalski, Bernard Klein, Elmer Beckwith, and the unnamed photographers for Park Forest's Camera Corner, the Mayer and O'Brien Public Relations firm, and Star Publications.

One caveat. The selections herein were made by the author in an attempt to mirror the Village's story. It is, by definition, incomplete. It is hoped, however, that the images stir both memory and appreciation.

And one more thank you. This work could not have been completed without the patient aid and loving support of my wife Penny Shnay.

Jerry Shnay

INTRODUCTION

Park Forest, Illinois, began life on a post-World War II drawing board as a "castle-in-the-sky" plan to provide good housing for returning veterans. It quickly became both a symbol of suburban growth and a community imbued with a new kind of social identity. Today, less than 55 years old, it has emerged as a strikingly diverse community, aware of both its identity and its history.

But 50 years is less than one's normal life span. Such a short span in the life of a community leaves barely enough time for recollection, let alone reflection. There are people still alive that recall those early years. Yesterday's youthful pioneer is today's still-active senior citizen. One sees many of the same faces pictured here, changing with the years.

In a sense, the history of Park Forest mirrors that of the nation—from the optimism of the 1950s through the economic realities of the last 20 years. Park Forest grew, prospered, faced challenges, and responded.

Park Forest's story is best told chronologically. There are no venerated historical buildings or monuments in the village. To be sure, there was that clock tower in the middle of the shopping center. But that, like a lot of other things we grew up with, fell victim to the times.

First, a few facts.

Park Forest has a population of 23,462, about 40 percent minority and is located some 40 miles south of Chicago; with its approximately 6 square miles straddling the Cook and Will County lines. It has a non-partisan form of government. A village manager handles day-to-day operations. A village president and six trustees, each serving a staggered three-year term, govern it.

Park Forest has some 3,900-apartment units and 5,700 single-family homes. Almost all the apartments (condominiums, co-ops, and rentals) were built when the village was founded. There are 18 parks in the village, including a large Central Park area in the heart of town. The Recreation and Parks Department operates one of the largest outdoor swimming complexes in the state, along with a tennis and health club, and an 18-hole municipal golf course. Park Forest has won two national All-America City awards and has been a finalist two other times, the last in the year 2000.

The village is carved up into four grade-school and three high-school districts. There are 17 houses of worship in the community, including a Conservative Jewish congregation, two Roman Catholic churches, and four United Protestant churches. The United Protestant movement got its start in Park Forest.

Next, a little history.

Park Forest was the first post-World War II wholly-planned community built in this country through private enterprise. It was designed as an answer to one of America's most desperate post-war concerns—that of decent housing for veterans. It was called a "dream city" and labeled a "G.I. Town."

Grand Rapids, Michigan, banker Carroll Sweet Sr. sold Chicago builder Nathan Manilow on the idea of such a post-war town. Manilow then persuaded Philip Klutznick, the Federal Public Housing Authority commissioner during World War II, to work with a new company, American Community Builders (ACB), in building this new way of life.

ACB was a conglomeration. Loebl and Schlossman, a Chicago architectural firm, and architect Richard Bennett signed on as did planner Elbert Peets and housing specialist Hart Perry. In March 1946, some underused land that encompassed the Indian Wood Country Club and farms in the southern tip of Cook County was selected as the site. First settlers began arriving in August 1948, even before units were finished. Living conditions for early pioneers were difficult; mud, spotty party-line telephone service, and flooded basements. It was desolate and far from work, but these hardy pioneers seemed determined to build an ideal community from scratch.

At a tent meeting in November 1948, Klutznick urged residents to take control of their own affairs and govern themselves. And they did. The first village meetings were held in a three-bedroom home used as a nursery school during the day.

Waves of people flocked to Park Forest. Civic participation seemed to be a way of life in the village. Park Forest's citizens needed schools for an exploding population. In 1951, residents approved a $1.25 million school bond issue by a 1,828 to 12 vote in the village. School doors were opened for the first time on September 14, 1953, and just in time for Park Forest to win the first of its two All-America city awards for those extraordinary efforts.

A second national honor came 24 years later in 1977. This time the village was honored for three projects: an area-wide housing service designed to rehabilitate deteriorating homes, a walk-in facility for troubled and runaway youth, and a volunteer commission which raised funds to furnish the equipment and landscaping for the newly created community center.

Early on, residential courts became the center of social activity. *Fortune* magazine editor William Whyte was fascinated by what he saw. He believed Park Forest's upwardly mobile middle-class residents, especially those who worked for large corporations, conformed to a strict, yet unwritten code of social conduct. He turned his theory into *The Organization Man*, a book that became a national best-seller in the 1950s and was one of the first volumes to explore the culture of post-war suburban life.

As Park Forest's population exploded, the small shops in the center of town became part of the largest regional shopping center in the area. The Plaza, as it was called, was a center of commerce for the entire south suburban area. It withered when other shopping centers were built in the 1970s.

After numerous unprofitable changes under various owners, village officials devised a plan in the early 1990s to turn the area into a smaller mix of stores and shops in a "downtown" area. Buildings were demolished and new streets built to accommodate the new mixed-area proposal. It was to be a new beginning at the start of a new century.

And one final note.

Most of the photographs in the book are about people—working and playing, planning and persevering. Most of the people in this book seem to be enjoying themselves. This book wasn't planned that way. It just happened. So enjoy.

One
DREAMS IN THE TENT

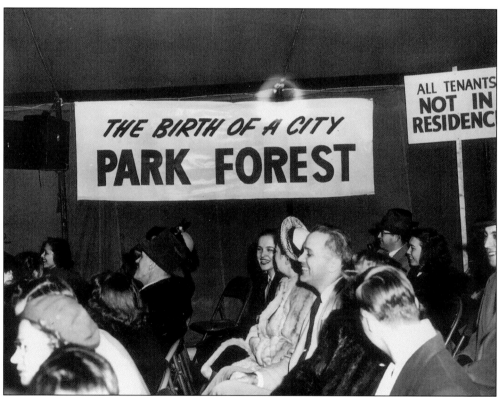

A severe housing shortage gripped parts of the United States in the first years after World War II. In 1946, a group of homebuilders and developers formed American Community Builders. They picked an underused area in the southern end of Cook County for their planned community. Residents began moving into still unfinished apartments in August 1948 and three months later, on November 27, 1948, inside a large tent, ACB President Philip Klutznick urged residents to form their own government. By this, ACB was forced to submit to the will of its tenants. Klutznick stayed on, living shoulder-to-shoulder with the people who were to be in charge of his community. "I was proud of my village. I lived there. It was my home." The sign proclaims the event at the tent meeting. Carroll Sweet Jr., who named the community Park Forest, said he did so because "it was near a park and a forest preserve."

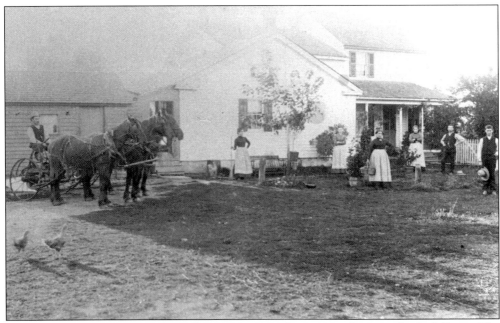

The Weishaar family farm, established in 1828, occupied a portion of present-day Park Forest. The farmhouse, in this picture from 1888, is now the site of Rich East High School on Sauk Trail. Identified, from left, are John M. Weishaar, Agatha Weishaar Fox, Elizabeth Fox Weishaar, grandmother Agatha Scheidt Weishaar, Mathilda Weishaar, Peter Weishaar, and Frank Poligrat.

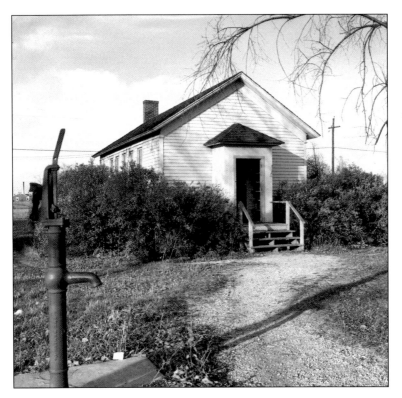

This small schoolhouse, located on Sauk Trail, served the grade-school students living in the area. With Park Forest booming, the structure quickly became obsolete. This picture was taken in November 1953, some three months after Rich Township High School opened its doors.

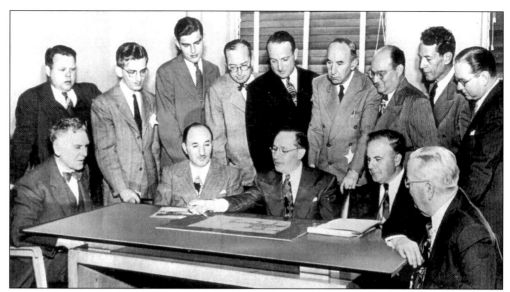

The American Community Builders Board is pictured here. Seated, from left, construction chief Allan S. Harrison, treasurer Nathan Manilow, president Philip Klutznick, architect Jerrold Loebl, and board member Carroll Sweet Sr. Standing, from left, Carroll Sweet Jr., comptroller Israel Rafkind, secretary Hart Perry, architects Richard M. Bennett, and Norman S. Schlossman, utility engineer Charles Waldmann, construction advisor Joseph Goldman, town planner Elbert Peet, and public relations counsel Nathan E. Jacobs.

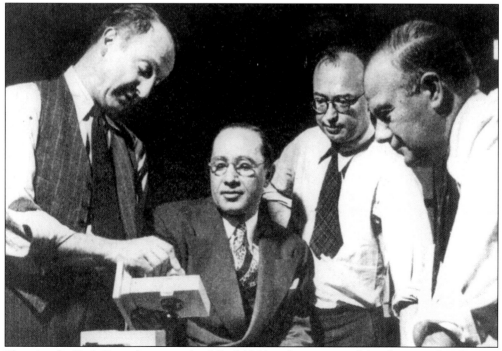

Planning for Park Forest began in the fall of 1946 with meetings of developers and architects. Here, architects Norman Schlossman (left), Richard Bennett (second from right), and Jerrold Loebl (far right) show Philip Klutznick the door locks to be installed in all units.

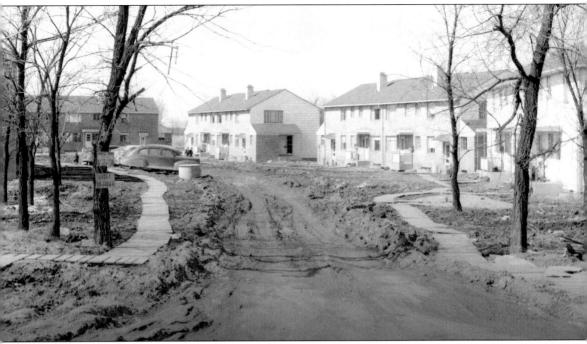

Newly completed rental units in March 1949 are already occupied. Note the wooden "duckboards," which passed for sidewalks. When the community was formed, these boards were the only way to avoid mud that seemed to be everywhere.

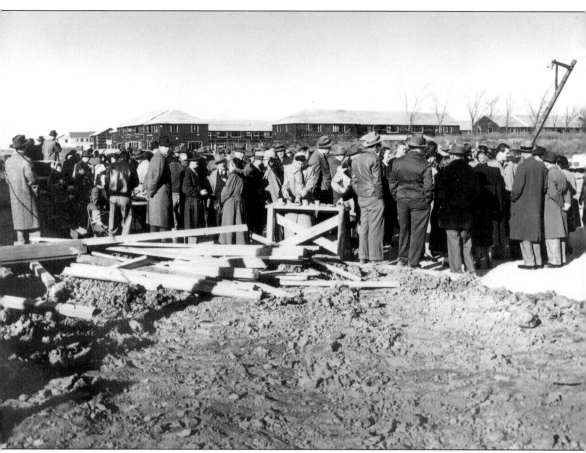

Pioneer residents gather for the tent meeting on November 27, 1948. It's easy to see the rushed state of development. Units still under construction can be seen in the background as residents pick their way through the debris, angled light poles, and ever-present mud.

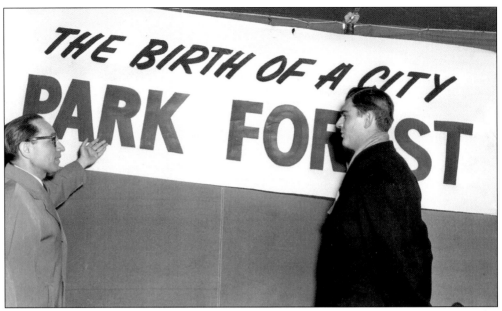

Philip Klutznick explains his plans for the new community to ACB secretary Hart Perry, right, just before the tent meeting.

A costumed bell ringer was used to summon residents into the tent.

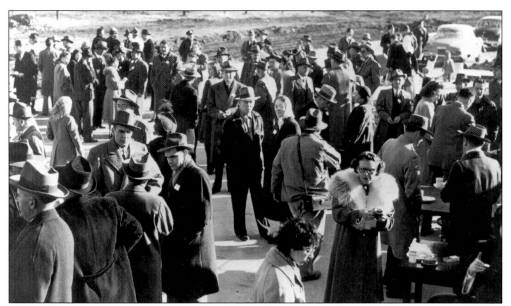
Hot coffee outside and food inside helped keep the more than 600 residents warm prior to the tent meeting on November 27, 1948.

One of the numerous young families makes themselves comfortable before the start of the tent meeting.

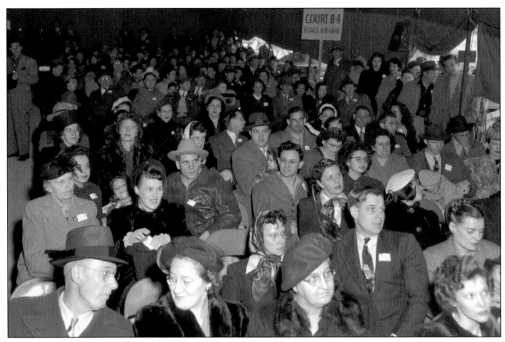

A portion of the crowd inside the tent just before the meeting began.

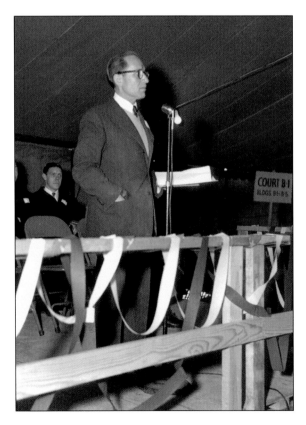

Philip Klutznick, who lived in Park Forest for years, speaks to residents about the community's future.

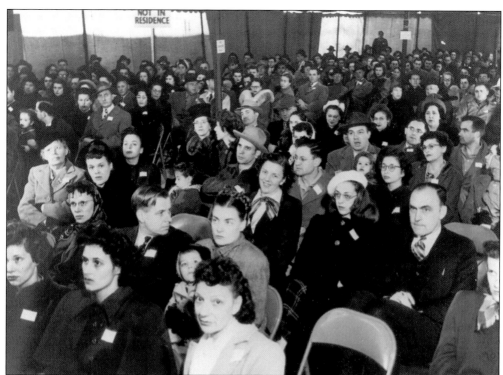

Residents anxiously crowd into the tent at the historic town meeting to hear about plans for the new town

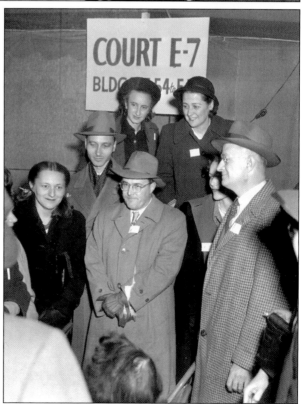

A group of Park Foresters wait underneath a sign designating their residence.

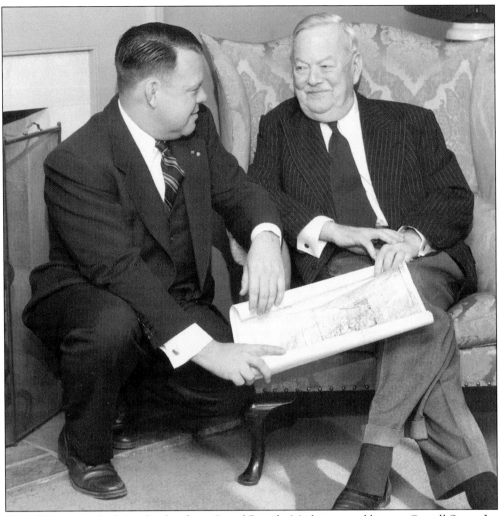

Carroll Sweet Sr. (right), a banker from Grand Rapids, Michigan, and his son Carroll Sweet Jr., were two of Park Forest's founders. It was the father who insisted that such a planned community was possible. His son took part in much of the day-to-day development of the community, including the delivery of 5-gallon water jugs to the first residents.

Two

GROWTH

In the first years of its existence thousands flocked to Park Forest. They endured flooded basements, mud, poor phone service, and other nuisances. But the village grew and prospered. Apartment courts became the center of social activity. A little shopping area in the center of town seemed to grow by the week and quickly turned into the first post-war regional shopping center in the country. By 1951, ACB was successfully selling single-family homes. As a result of a massive outpouring for a 1951 referendum, voters agreed to tax themselves so their children could attend local schools.

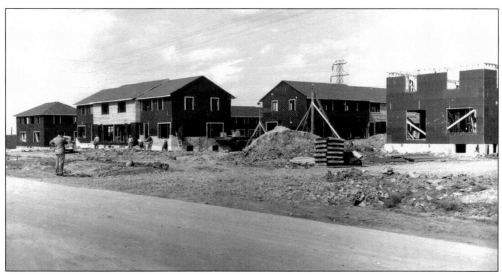

Rental units under construction in 1948, during Park Forest's first few months of existence, were quickly snapped up. Some residents moved in even before their units were finished.

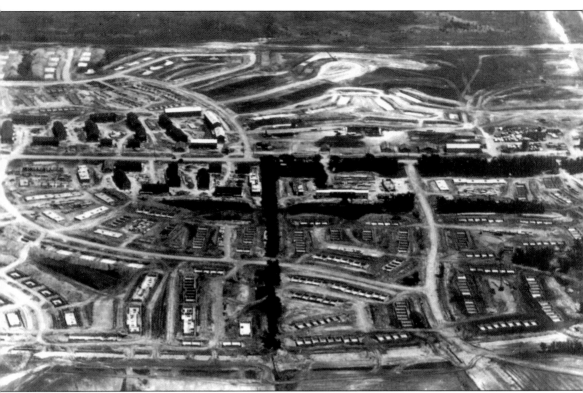

This aerial view of Park Forest, taken early in 1949 and looking to the east, demonstrates the quick pace of home building in Park Forest. Birch Street in the upper left curves towards the original units, just out of the picture on the left, at 26th Street and Western.

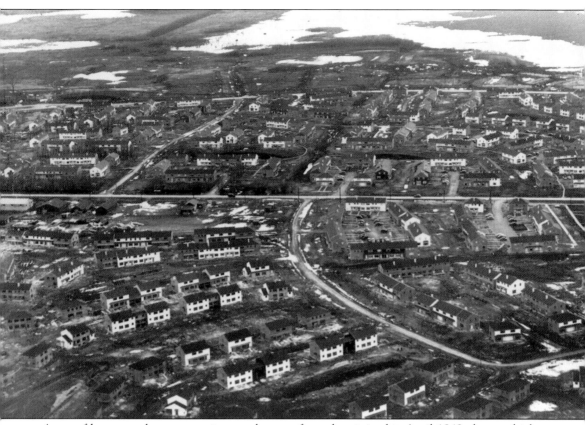

A sea of homes under construction can be seen from the air in this April 1949 photo, which looks west. Western Avenue, the main north-south street in the community, is the thoroughfare in the center.

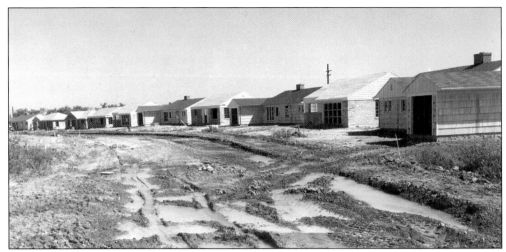
A typical sight in Park Forest during the early 1950s was of new homes springing up on an unpaved street. ACB's original goal was to sell 500 homes in one year. At one stage they sold 500 in 30 days.

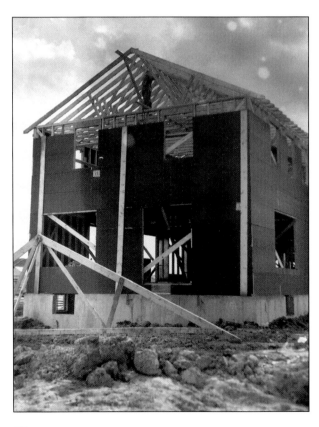
Pictured is a two-story rental unit under construction in 1948.

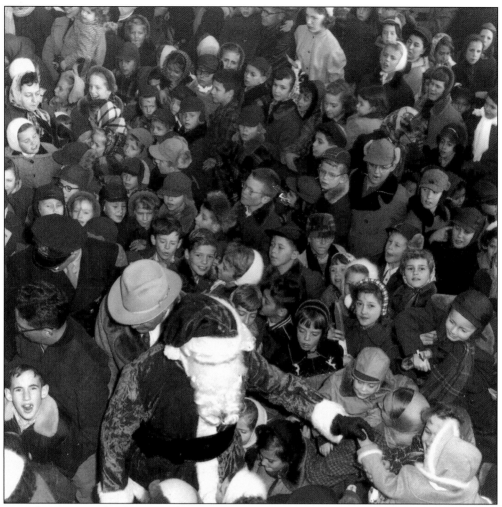
Carroll Sweet Jr. takes his turn playing Santa Claus to children during the Christmas of 1950. By this time, Park Forest had a population of nearly 5,000.

Excavating for basements in one of the first rental units proved to be a muddy task.

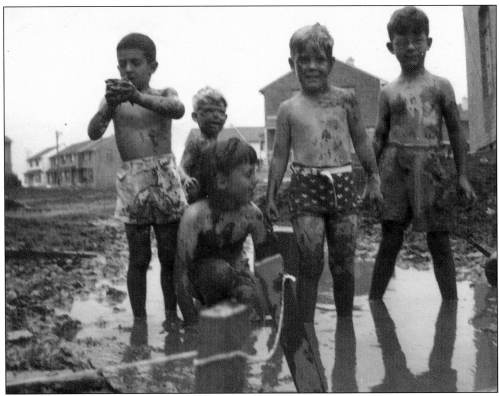
Mud, mud, everywhere. That's what faced pioneers moving into apartment courts in 1949. Here, children seem to find a happy moment sloshing in the muck. The scene was in Court E-8 on Western Avenue.

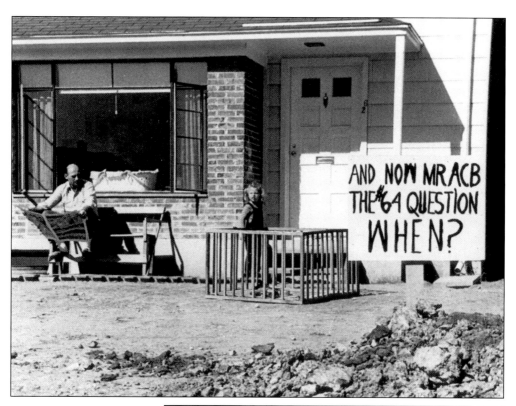

Early residents demanded American Community Builders fix problems of mud and basement flooding. In this September 25, 1949 photo, a resident of Elm Street shows his displeasure with the lack of pavement in front of his apartment unit.

As the single-family home boom continued, American Community Builders gained considerable attention in the magazines of the day. ACB was able to engender much publicity throughout its early days, including a February 14, 1948 article in *Collier's Magazine* that labeled Park Forest the city of the future.

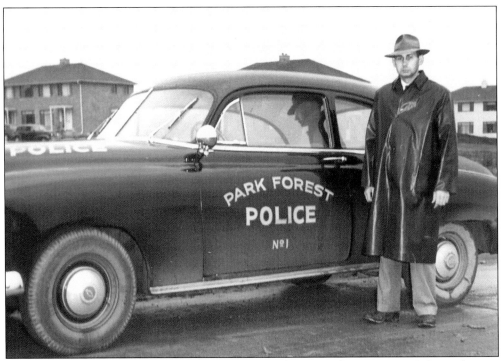

Park Forest's first Chief of Police, David Wilson, stands next to the community's first police car in a picture taken June 1, 1950.

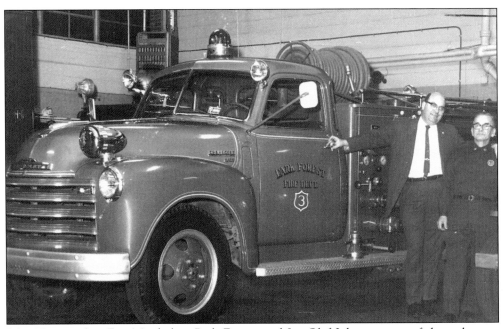

John Towner, first Fire Marshal in Park Forest, and Lt. Olaf Johnson, one of the volunteer firefighters, during the village's early years.

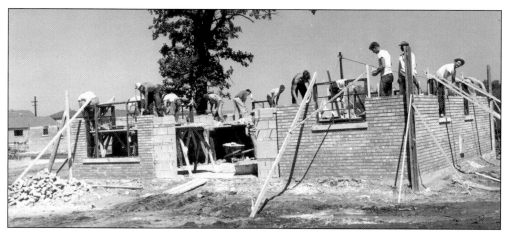

A dozen workers congregate on the walls of a house under construction. This photograph how large crews were able to build houses quickly. Materials were supplied to home sites on a daily basis, although early settlers recalled how construction of homes was delayed when one supplier failed to deliver supplies at a given time. ACB used its own lumber shop and concrete yard to hasten home building.

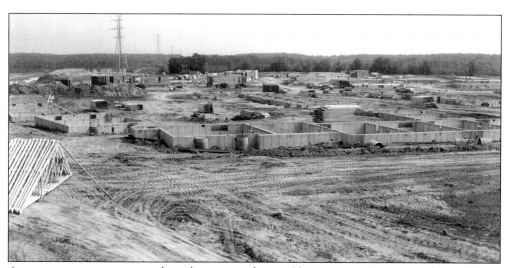

Apartments were constructed in almost record time. Here, one entire courtyard unit, C-4 at 154-164 Dogwood, is being built. Note that while roof framing, on the left, is waiting to be put into place, other courtyard units in the distance are also underway. This kind of mass production allowed for both cost savings and swift large-scale building.

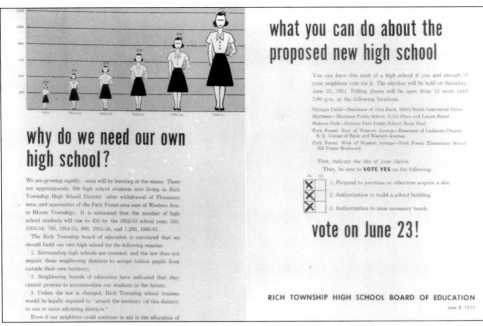

Early residents pushed for a high school to call their own and mobilized community support for the construction of a school in Park Forest. This was part of a brochure explaining some of the reasons the community needed a high school. Voters approved the referendum by a 1,812 to 12 vote and paved the way for Park Forest's first All-America City award.

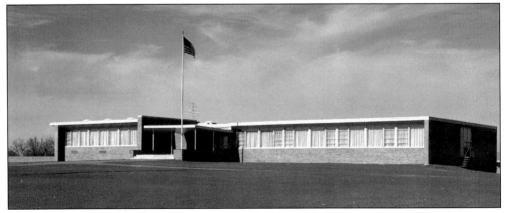

Rich Township High School, the project that helped Park Forest win its first of two All-America City awards, opened on a 55-acre site on Sauk Trail donated by American Community Builders.

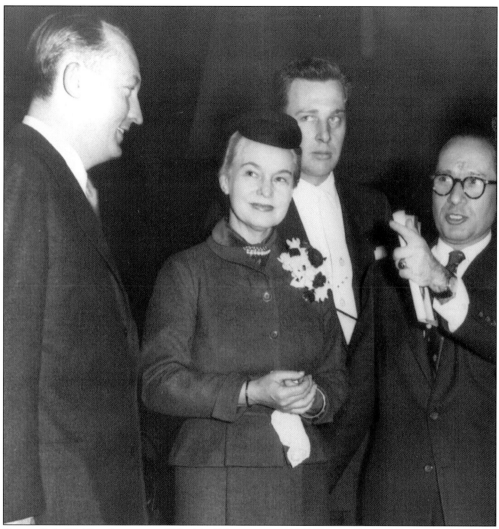
Oveta Culp Hobby, Secretary of Health, Education, and Welfare in the Eisenhower cabinet gets a tour of the new high school by the head of the school committee, James Patterson (left), and Philip Klutznick at the school's dedication ceremony on December 6, 1953.

Eager house hunters quickly snapped up single-family homes for sale. On weekends large crowds came to Park Forest to view the models on display.

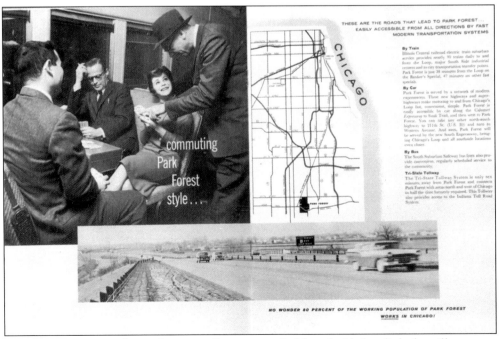
In order to attract residents, American Community Builders decided to link the village to an easy commute to Chicago via the Illinois Central rail line in this 1950 brochure.

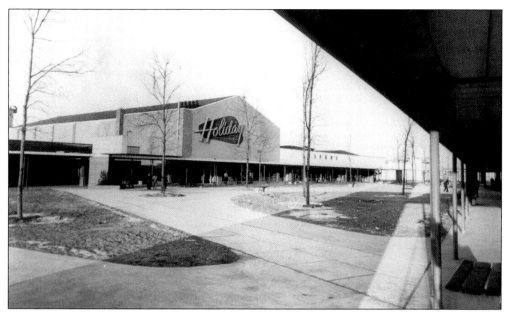

The Holiday Theatre dominated the center of the Park Forest Plaza, as other store front areas were under construction. The movie theater featured seating for 1,110, a "cry room" where parents could calm their infants, afternoon teas, free coffee, and snacks. The movie house was also used as a site for religious services for various denominations while permanent houses of worship were under construction. Now called the Park Forest Theatre, the film house continues in the same location today.

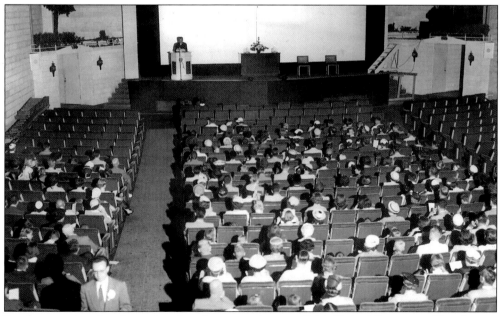

Sunday morning church services for what was to become Faith United Protestant Church were held in the Holiday Theatre. At one time, the building was also the site of Saturday morning services for the Reform Jewish Congregation Beth Sholom. (Photo courtesy of Faith United Church.)

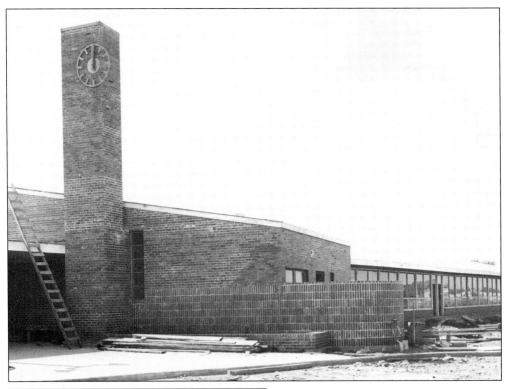

Park Forest's clock tower, the symbol of its commercial development, was an obvious emblem for the village. Here, in this 1953 photo, a smaller version of the clock tower dominates the picture during construction of Lakewood School.

The Park Forest clock tower was located in the middle of the rapidly growing shopping center in the center of the new village.

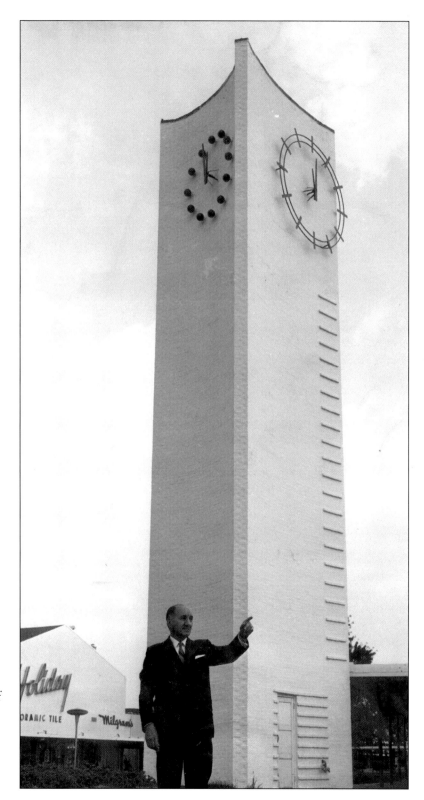

Developer Nathan Manilow, one of the founding fathers of the Village, points to the future in front of the clock tower.

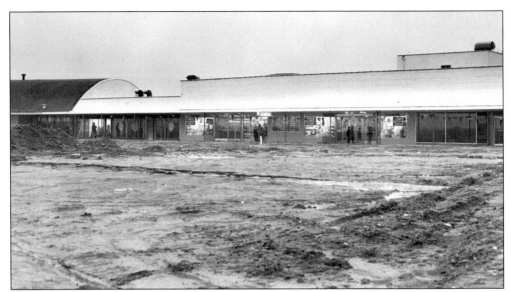

In 1950, five and dime stores still had a commercial future when Kresge's opened its doors in November of that year. It's not hard to see that the shopping center was still undergoing growing pains, as seen by the condition of the ground in front of the store.

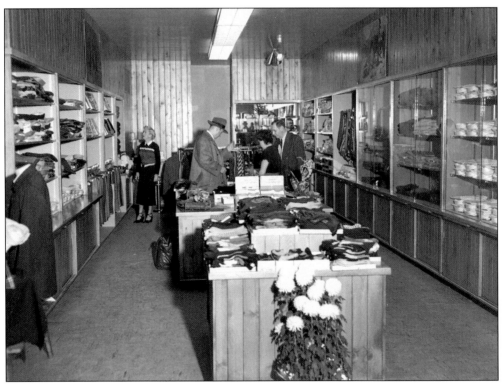

Fidlers Ltd., the first men's clothing store in Park Forest, opened on November 19, 1951. The small store was located between the Jewel Food store and Kresge's. When it opened, Fidler's was the 35th retail outlet in the shopping center. Proprietor Carl Fidler (behind the counter) is seen talking to a salesman, while his wife seems to be checking the merchandise.

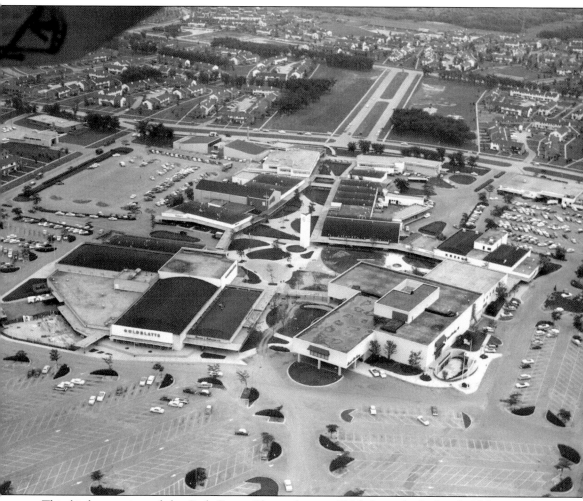

This birds-eye view of the Park Forest Plaza taken in 1956 shows both the Goldblatt's and Marshall Field's Department stores—the clock tower is in the center. Note the cars parked (upper right) next to the Kresge store and to its left the Jewel Foods store. This picture shows the original configuration of the Plaza.

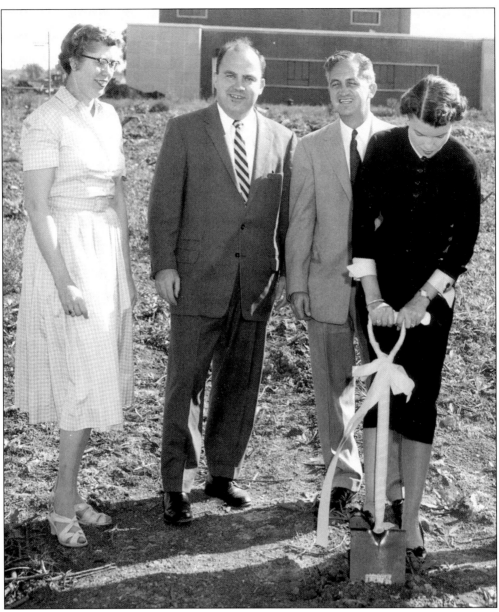
Groundbreaking for the Park Forest Public Library took place in 1955. At the time the library's temporary home was part of an overcrowded Village Hall. Seen, from left, Head Librarian Leona Ringering, Village President Bernard G. "Barney" Cunningham, ACB representative Tom McDade, and Chairman of the Library Board Enid Theurmid, wielding the ceremonial shovel.

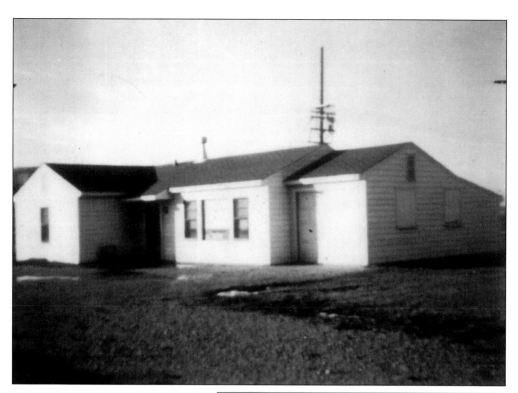

Elizabeth Waldmann ran a nursery school in this building at the intersection of 26th Street and Western Avenue during the day. By night it served as Park Forest's first Village Hall. (Photo courtesy of Faith United Church.)

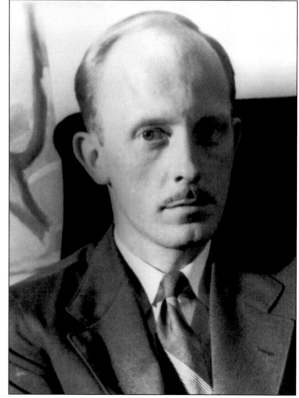

Dennis O' Harrow was elected the first Village President in 1949 in a spirited 13-person election. O'Harrow, a city planner, spent two years in office.

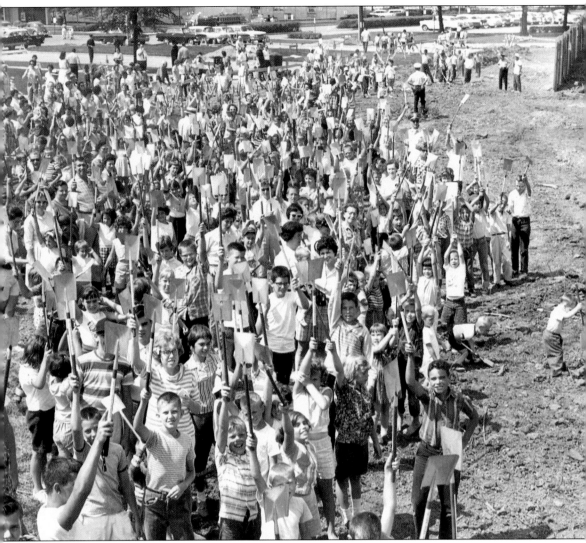

Every groundbreaking ceremony became a village event. This was the scene at the Sears groundbreaking ceremony in 1962. Children were invited to take part and each was given a small shovel. At least one child was more interested in digging on his own (far right) than in having a picture taken.

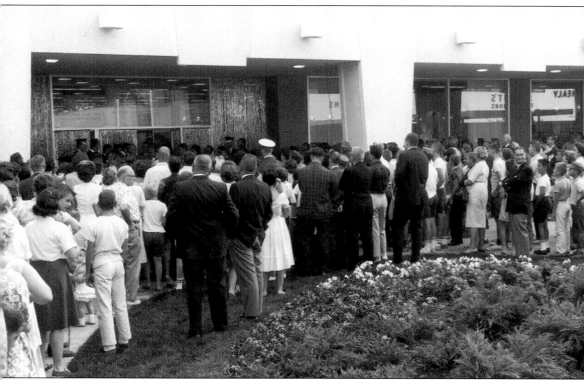

It's the first day of business for the Sears store, and Andy Frain ushers have to hold back the large crowd awaiting the opening of the doors.

hen Park Forest was a year old, we couldn't do much more than a hair and sole bi

In November 1969, the Park Forest Plaza ran this ad in newspapers outlining the growth of the village's commercial center, from little more than a barbershop to what was then one of the

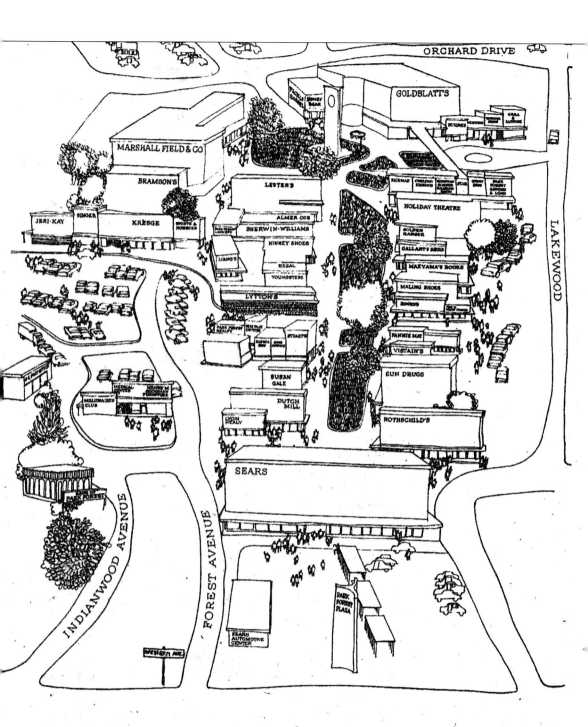

Now, on the Village's 21st birthday, we have everything you need to make a birthday happier and your life a bit more enjoyable. **PARK FOREST PLAZA**

largest outdoor shopping malls in the Chicago area and the first post-war shopping center to be built in the United States.

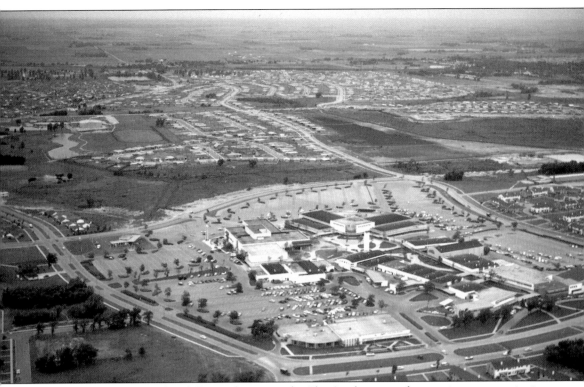

Another aerial view of Park Forest showcases the Plaza's relation to the growing community in the mid-1950s. The campus of the newly constructed high school can be seen in the upper left. Homes toward the top of the photo, built in the early 1950s, demonstrate Park Forest's population explosion.

Three
A Photo Album

All-America City awards (given in 1954 and 1977), parades, citizen involvement, and pride of place were evident throughout Park Forest's history. A *Fortune* magazine editor, a Vice President running for re-election, an Illinois governor, and an Illinois governor-to-be, all visited Park Forest. Some things didn't last. Other things flourished. Here is a kaleidoscope of photos that show the many aspects of life in Park Forest.

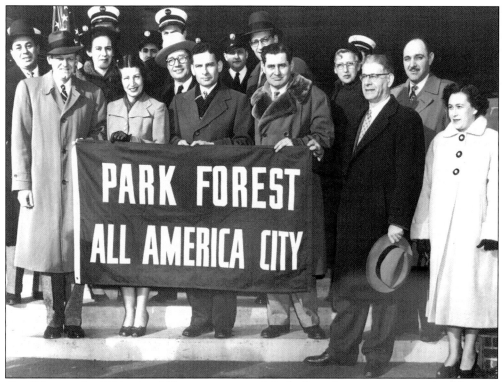

On February 1, 1954, the fifth anniversary of Park Forest's incorporation, the National Municipal League presented the community with an All-America City award. Identified from left, ACB engineer Ed Waterman, Trustee Frank Norris, Mrs. Waterman, Mrs. Norris, Philip Klutznick, Village President Robert Dinerstein, Jack Star, Edward Cohen (in fur collar), Mrs. and Mr. Blumenthal, and Mr. and Mrs. Bernard Udkoff (far right).

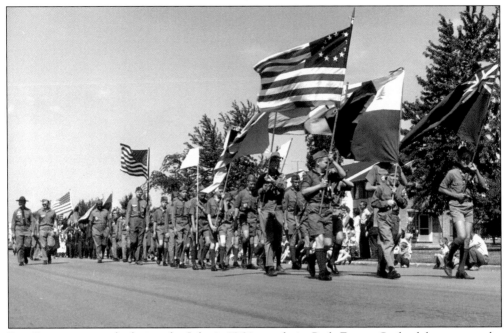

Boy Scouts on parade during the July 4, 1964 parade in Park Forest. Such elaborate parades were the norm during the first 25 years of the village's existence. In recent years the Independence Day parade has become less structured with an informal "do-it-yourself" style.

The All-America City banner (center) takes its place alongside the flag of the United States and the Illinois state flag on the poles at the entrance to the Park Forest Plaza. In later years this site was occupied by the Sears, Roebuck & Co. store.

In 1952 one could buy a 967-square foot, two-bedroom home for $11,995. The house included a hot water tank, all fixtures, landscaping and an asphalt driveway.

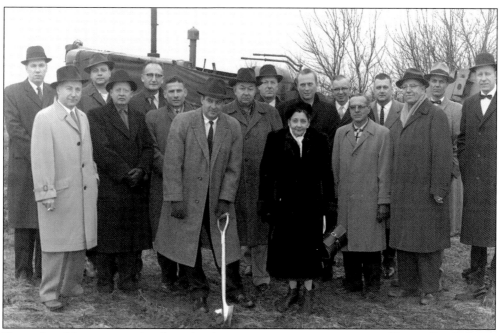

Groundbreaking ceremonies for schools were a common occurrence. Here officials break ground for Rich Central, one of three high schools serving Park Forest residents. Identified are (fourth from left, towards center) Cliff Wavrinek, Dave Perryam, Robert Dinerstein, and Robert Ringwood (holding shovel). Third from right towards center are Russ Douglas, Harry Cooper, Ned Mayhew, school superintendent Dr. Robert Andre, George Ritter, and teacher Minnie Rio.

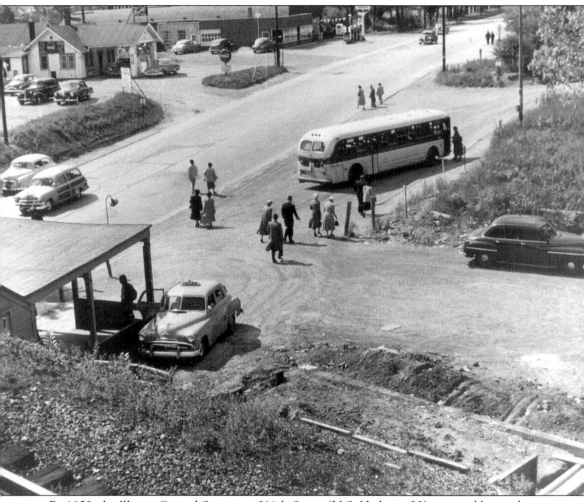

By 1950, the Illinois Central Station at 211th Street (U.S. Highway 30) was used by residents as a transportation hub to and from Park Forest. This scene, looking west along 211th Street, shows commuters boarding a waiting bus with the ever-present taxicab waiting for passengers.

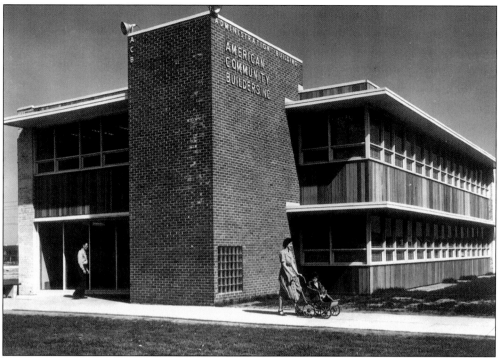

American Community Builders was headquartered in Park Forest in the 1950s where the company tried to work with residents in 3,000 apartments and 5,000 homes.

First place in the July 4, 1953 parade in Park Forest was won by the Park Forest Homesteaders Association, one of the most influential citizens' organizations in the village's early days. Here, they celebrate the community's population boom.

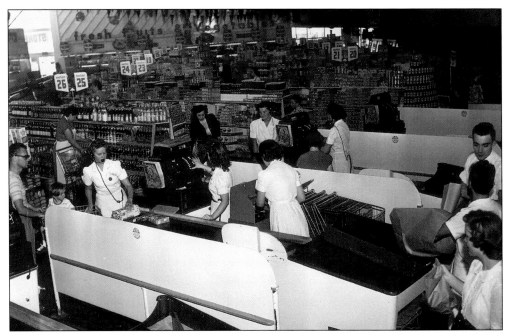

The Jewel Food store handled much of the village's shopping needs for nearly 50 years and used a number of innovations including that of microphones for clerks. The supermarket first located in the Plaza and then to a larger location, across from the center. In 1999 Jewel closed its doors, but two years later the site was taken over by Sterk's Super Foods.

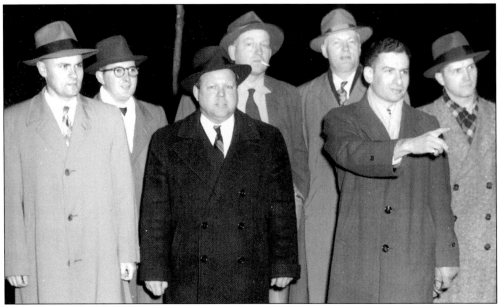

Village Trustee Robert Dinerstein (second from right) points the way to a lighted area in February 1952, as lights are turned on in the homes for sale area. Others pictured are, from left, Village Manager Ed Meisenholder, Tom Rettenbacher of Monroe Electric, Carroll Sweet of ACB, Ed Kern of the Homesteaders Association, E.B. Miller, a Public Service Co. representative, and J. Brandl of Monroe Electric.

The Jewel store reportedly had the highest per capita volume of business in the entire Chicago area. That's why it operated a moving belt carry out service. Upon paying for groceries, customers were given numbers to attach to the windows of their automobile. Groceries were then carried to the rear of the store, where consumers' cars, like the six pictured here, would drive up and customers would pick up their food.

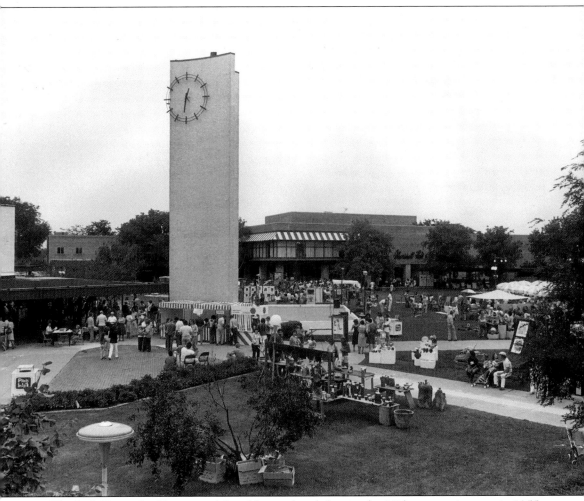

The Park Forest Art Fair, one of the oldest such exhibits in the Midwest, got its start in 1955. Visitors to the Air Fair could view artistic creations underneath the canopies and awnings in the Park Forest Plaza. The clock tower base shaded both artists and patrons, while other artists displayed their wares in front of the Plaza stores. (Photo courtesy of Bob Smart.)

Visitors to the Art Fair were often serenaded as they strolled past the various booths.

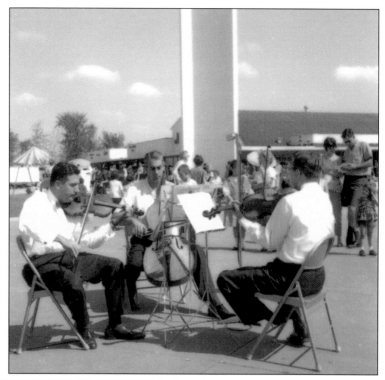

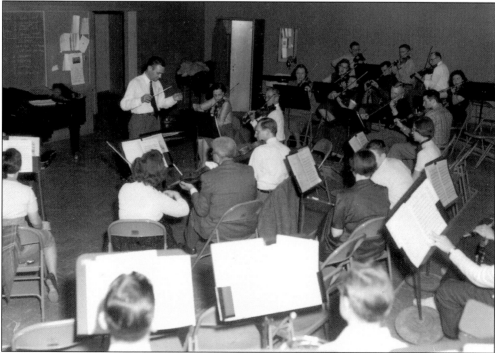

The Park Forest Symphony is seen here in a 1955 rehearsal session. The musical group flourished during the village's early years. In later years, the Illinois Philharmonic Orchestra, with headquarters in Park Forest, became one of Chicagoland's best musical organizations.

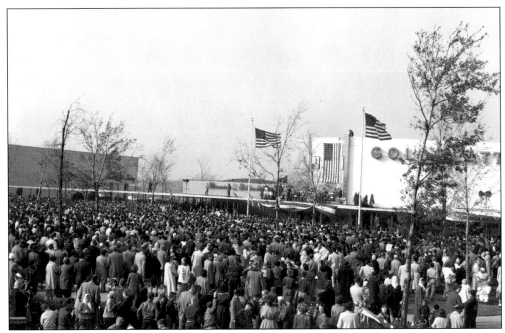

Thousands turn out to welcome Vice President Richard M. Nixon as he made a campaign stop in Park Forest during the 1956 election campaign. This was part of a whirlwind daylong tour that took him through a number of South Suburban communities. The Vice President can be seen in the distance, speaking from a platform erected near the Goldblatt's store.

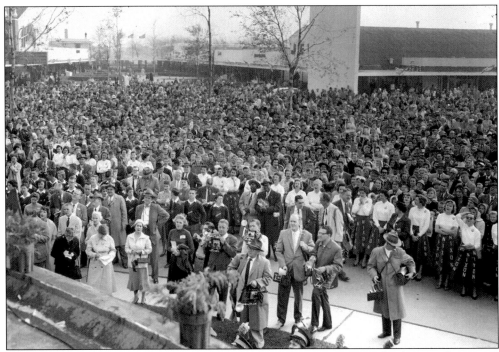

Nixon returned to Park Forest on October 29, 1960, while campaigning for the presidency, and again spoke to a large crowd in the Plaza.

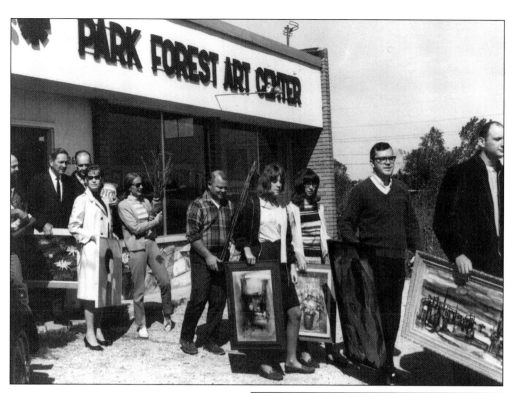

In 1969, the park Forest Art Center moved from its home on Monee Road into the basement of the library. Helping with the move are, from left, Phil Mundt, Jim Lane, Jim Bogar, Willa Lane, Mary Lou Marzuki, Jim Marzuki (later a state representative), Vicki Lane, an unidentified helper, F. Patrick Kelly (later a Village President), and Tom Ascher.

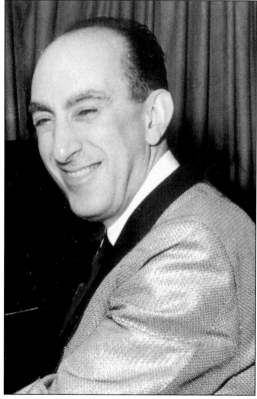

Legendary jazz pianist Art Hodes (1904–1993), a major influence in music for more than 60 years, called Park Forest his home.

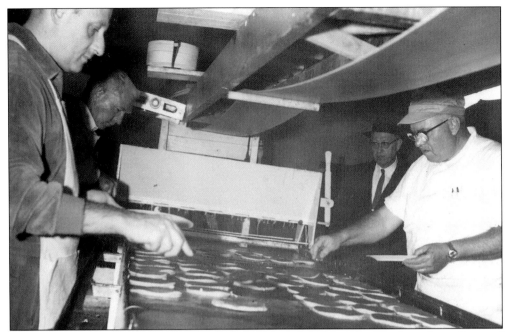

The Pankatron Machine pours and cooks dozens of pancakes simultaneously, and is still part of the Kiwanis Club's Pancake Day, held every autumn in the village for 50 years. Here, Kiwanis Club members Dick Wolfe and Bob McGuire man the machine. At left, Emil Houfek awaits. Lou Alleson, credited with inventing the "Pankatron," is at the right. The entire machine consists of a large griddle, a massive pourer, and a series of belts and pulleys that transport hot pancakes to waiting customers.

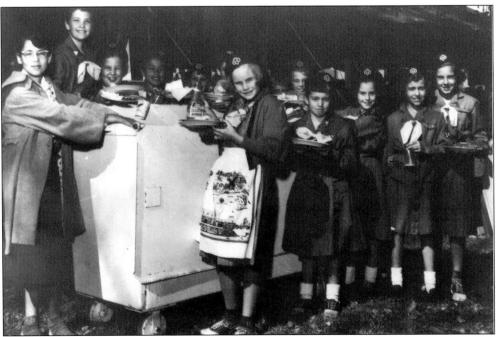

Girl Scouts helped serve food during a Kiwanis Club Pancake Day in the 1950s.

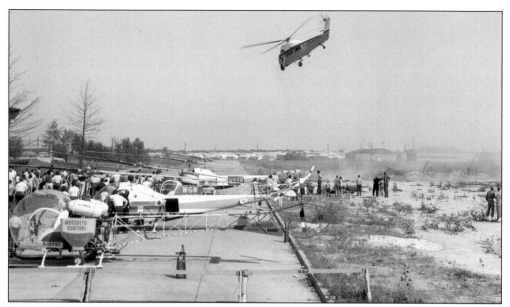

In 1964, the Hollymatic Corp. opened its heliport. The area was envisioned as a way to attract new business into the area. But in 1969, the village purchased the landing area. Helicopters from two radio stations and the Cook County Mosquito Control unit are on the ground, while another ship from Chicago Helicopter Airways prepares to land.

The heliport site was later sold to the State of Illinois to be used as part of a residential home for those with developmental disabilities. Here village and state of Illinois officials exchange a check. Seated, from left, Village President Bernard G. Cunningham, an unidentified state official, and Joseph McGrath. Standing, from left, Trustees Mayer Singerman, J. Ron McLeod, and Rudy Lachmann.

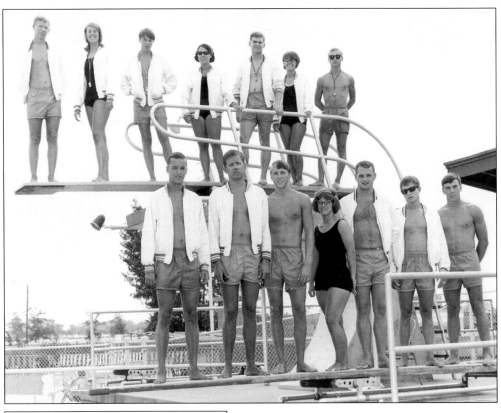

Lifeguards at the Aqua Center pose for a picture in 1966.

Illinois Governor Richard Ogilvie is the speaker at the dedication of the Elisabeth Ludeman Developmental Center, the residential home complex built on the site of the old Heliport.

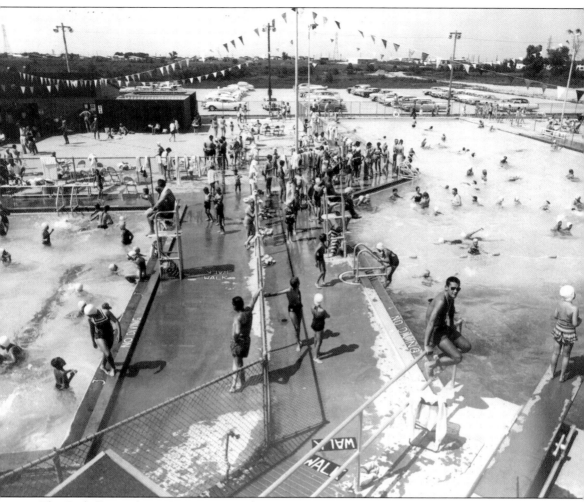
The Park Forest Aqua Center, an outdoor swim center, was financed and built by private contributions but was later purchased by the Village of Park Forest. This photograph was taken shortly after the Aqua Center was opened in 1954.

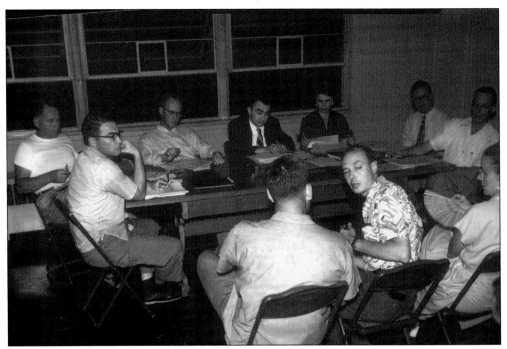

A meeting of the Board of Trustees in 1953 includes Village President Henry X. Dietch (center) and Trustee Ruth Skaggs, the first woman elected to office in the village.

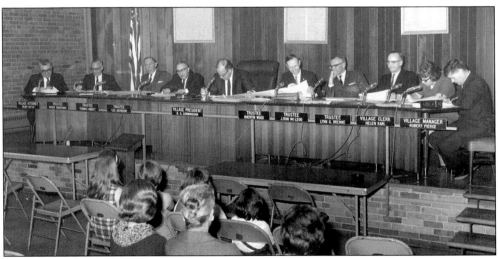

Pictured here is the Park Forest Board of Trustees in a 1968 meeting in the Village Hall. From left, Village Attorney Henry X. Dietch, Trustees Mayer Singerman, Thomas Abbott, Leo Jacobson, Village President Bernard G. Cunningham, Trustees Quentin Wood, J. Ron McLeod, and Lynn Brenne, Village Clerk Helen Karl, and Village Manager Robert Pierce.

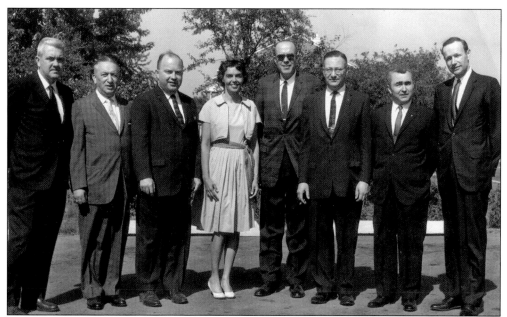

Village officials line up for a picture on July 4, 1964. They are, from left, Trustees James Glennon and Leo Jacobson, Village President Bernard G. Cunningham, Village Clerk Gretchen Haverkamp, Trustees William Murphy and Rudy Lachmann, Village Attorney Henry X. Dietch, and Trustee Quentin Wood.

Retired Appellate Court Judge Anthony Scariano Sr., a former Village Attorney, who also served in the state legislature, and as head of the Illinois State Racing Board.

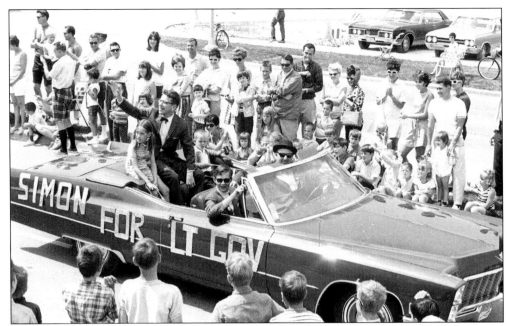

For decades, candidates for state office took seriously Park Forest's importance in the political process. Here Paul Simon, running for Lieutenant Governor on the Democratic ticket, waves to an Independence Day parade crowd during the 1968 parade. Simon lost the race and later served the state as a U.S. Senator.

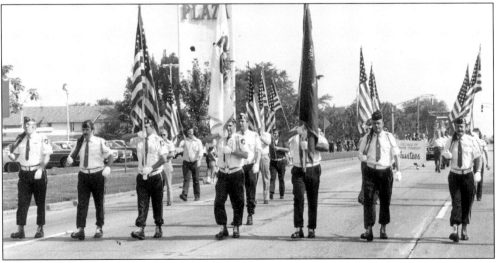

Park Forest's reputation as a "G.I. Town" for war veterans was evident during parades as the traditional color guard always had special significance for residents.

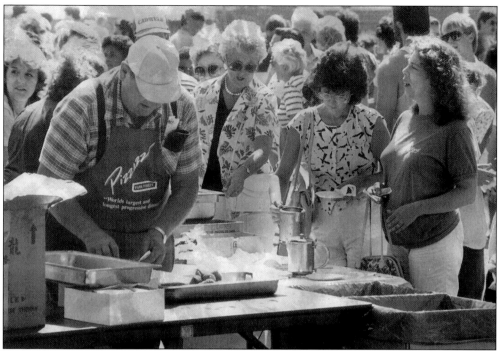

"Pizzaz," billed as the "World's Largest and Longest Progressive Dinner," was a feature of Park Forest life in the 1980s. Businesses, civic clubs, and religious groups—all offering food or drink—catered to thousands who flocked into the village over the Labor Day holiday.

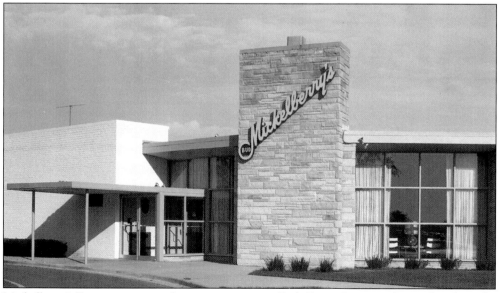

Mickelberry's Restaurant was a dining institution in Park Forest for more than a decade in the 1950s and 1960s.

The Park Forest Public Library, opened in 1955, has one of the largest collection of materials in the Suburban Library System.

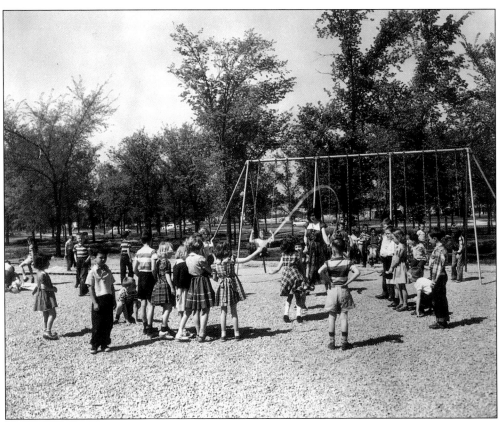
A school playground near Forest Boulevard was used as a selling point for Park Forest in the early 1950s.

In 1968, George and Jo Maeyama, right, and their daughter Meredith shared their home with Lena Diomer (left), a foreign exchange student from France. The Maeyamas were early residents and their bookstore was a fixture in Park Forest for decades. A son, Robert Maeyama, is the current Park Forest Police Director.

Non-partisan elections have always been part of Park Forest's political tradition. Here Village President Ralph Johnson (holding calendar), checks dates for a candidate forum in 1974 with Trustee Joseph Roth (holding pen). Others identified are Mrs. Lee Yates (far left), Loretta DeMarco, and Edward Kirk (far right).

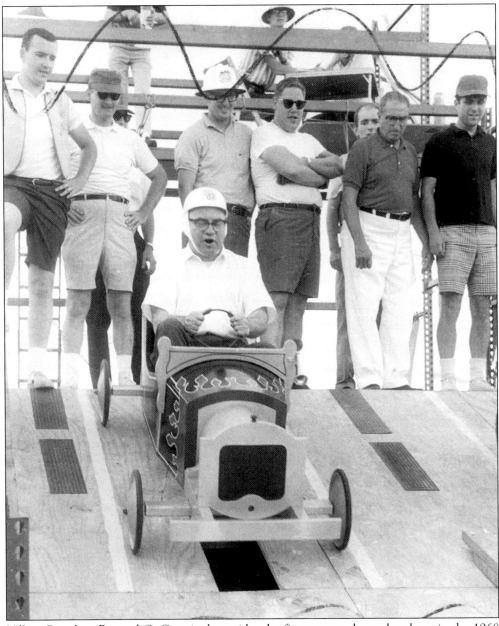

Village President Bernard G. Cunningham rides the first racecar down the chute in the 1968 Oil Can Derby staged on Orchard Drive.

Village President Henry X. Dietch shows good form as he rolls the first ball down the Park Forest Bowling Lanes on September 1, 1954. The lanes were part of the Park Forest scene for more than 30 years. The building was demolished during the reconfiguration of the new Downtown in the 1990s.

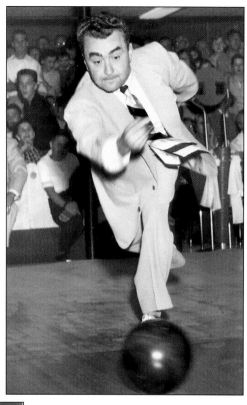

Village President Mayer Singerman enjoys a snack with some friends at the Apple Lane block party in 1974. (Photo courtesy of the Muchnik family.)

Past presidents of the Park Forest Garden Club pose for a photograph in August 1971. They are, from left, Miss Lynn K. Hurst, A.J. Eremouw, Lee Castilli, W. Dixon Clark, and Garrison Schroeder. The Garden Club, one of the oldest organizations in the village, is still active today. It holds a semi-annual plant sale and members are involved in all phases of community life.

Thomas McDade (1915–1992) came to American Community Builders in 1952 as head of sales after working for the Chicago Housing Authority. This began more than a 30-year association with Philip Klutznick and his various companies. After retiring in 1985, McDade moved back to Park Forest and was active in community affairs until his death.

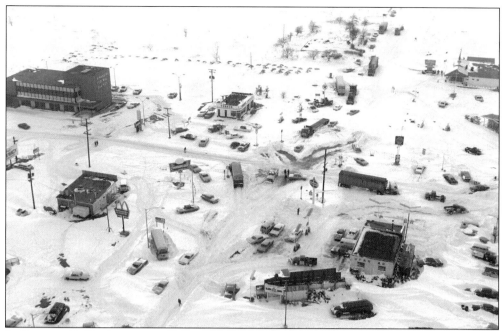

In January 1967, the entire Chicago area was blanketed with a record-setting storm that dumped nearly 25 inches of snow on the ground. An aerial photo shows the normally busy intersection of Western Avenue and U.S. Highway 30 one day after the storm hit.

Etel Billig is the director of the 26-year-old Illinois Theatre Center in Park Forest and has been a leader and creative force in the theatrical arts.

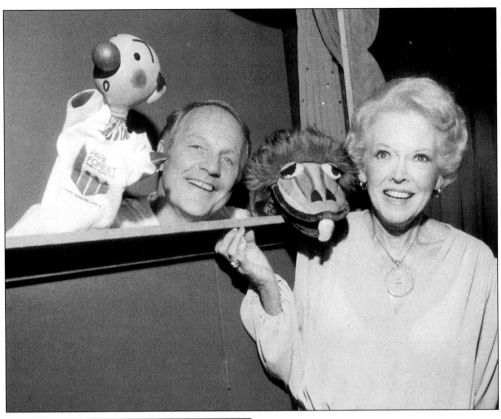

Everyone got into the act when Park Forest celebrated its 30th anniversary. Here, Kukla, of the fabled TV program *Kukla, Fran and Ollie*, wears a Park Forest shirt. In the picture are puppeteer Burr Tillstrom, Ollie, and Fran Allison.

Bill Simpson (1925–1996), a long-time resident, was a forceful advocate for African-Americans in the community.

In 1984, then-Secretary of State Jim Edgar (center) presented a building grant for its Energy Conservation Program to the Park Forest Public Library. Jim Brownlee of the Friends of the Public Library and reference librarian Gretchen Falk flank Edgar, once a resident of the village for a short time. He was later elected Governor.

Erwin "Pappy" Schechter (1915–1969), owner and publisher of the *Park Forest Reporter*, the weekly newspaper that kept track of village activities for more than two decades.

Philip Hecht (left), the first child born inside official village limits, sits with the first two children born in the village, Rebecca Joyce Findley and Roger Ruehl. Both Rebecca and Roger were born in November 1948. Philip was born on June 27, 1949.

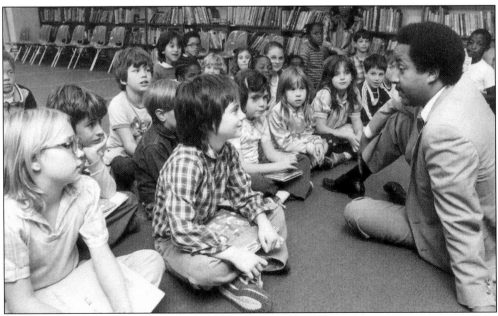

Village Trustee Ron Bean visits with school children in the public library in 1979. Bean was the first African American elected to office in Park Forest, serving as trustee from 1974 to 1981 and as village president from 1981 to 1986.

Members of the Park Forest Running and Pancake Club strut their stuff during the 1992 Independence Day parade. The club was one of the original sponsors of the 25-year-old Park Forest Scenic 10-Mile Run.

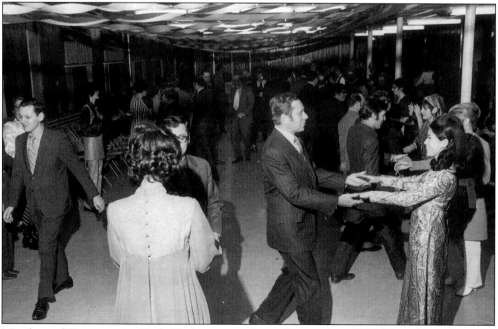

Members of Congregation Beth Sholom enjoy themselves in their 1971 "discotheque."

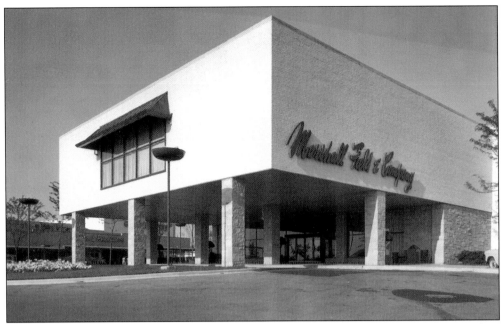

The two-story Marshall Field's building, built in the mid-1950s, was located just to the south of the Goldblatt's store and became one of the Plaza's anchor stores until it closed in the early 1990s. The presence of such a shopping icon in the south suburbs helped transform the Park Forest Plaza into a major regional shopping center.

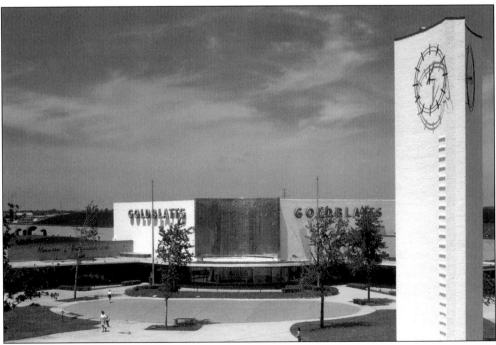

The Goldblatt's Department Store, which occupied the northwest corner of the Park Forest Plaza, and the clock tower, for decades a Park Forest symbol, were the most visible signs that the shopping center was growing.

William H. Whyte (1914–1999), whose book, *The Organization Man*, discussed the social activities and mores of Park Forest residents, theorized that workers in large corporations conformed to strict but unwritten codes of behavior. Whyte revisited Park Forest in 1977.

Harry Teshima was one of the Park Forest's pioneer residents whose work with the Unitarian Church's Social Action Committee helped pave the way for the integration of Park Forest in 1959.

Summer on a street in Park Forest in the 1960s.

School District 163 students take part in a 1977 junior high school musical *Flying High*.

Part of the 1975 Labor Day festivities was this Peanut Race for children.

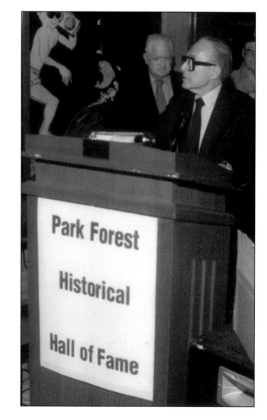

Philip Klutznick was the first inductee into the Park Forest Hall of Fame, established in 1989 by the Park Forest Historical Society as a way of honoring significant contributions by its citizens.

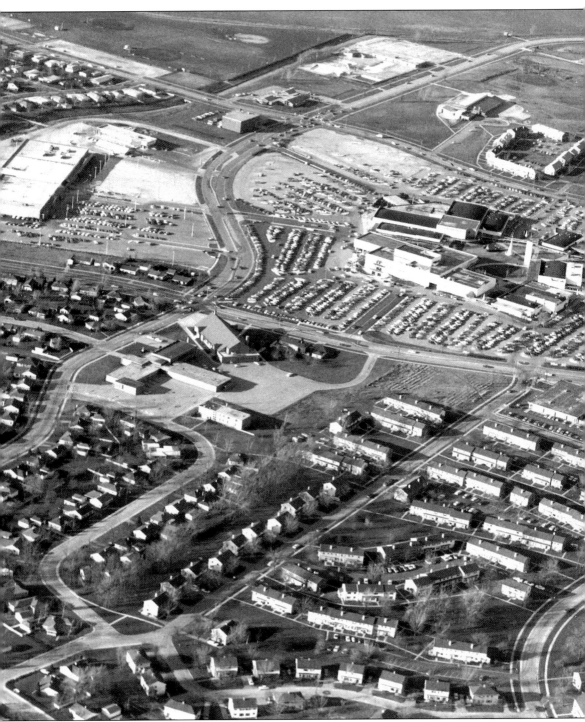
An aerial photo of the Plaza taken on December 16, 1967, at the peak of the Christmas shopping season, depicts the shopping center at the height of its commercial life. The photo demonstrates how important the Plaza was to the village's economic health. At the time, it was one of the largest shopping centers in the South Suburbs. But within five years, the center fell

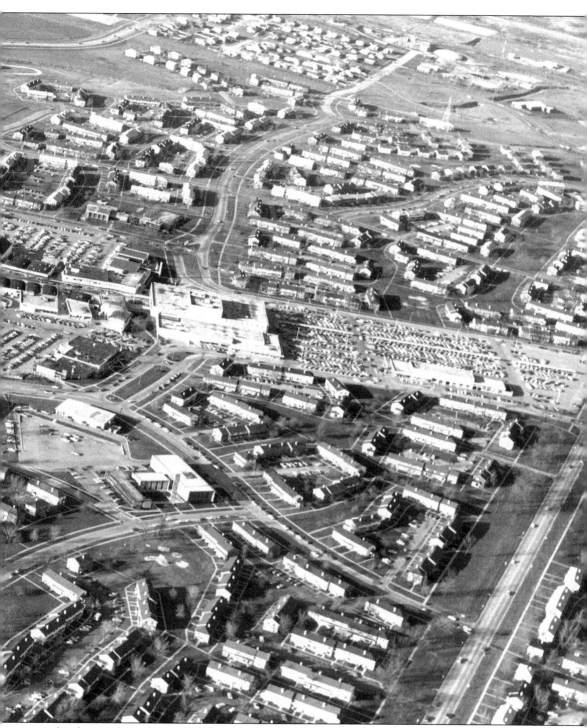

on hard times, beset by competition from larger malls. During the 1990s the Plaza and its other unsuccessful permutations were turned into a smaller mixed-use "downtown" of shops, stores, and housing.

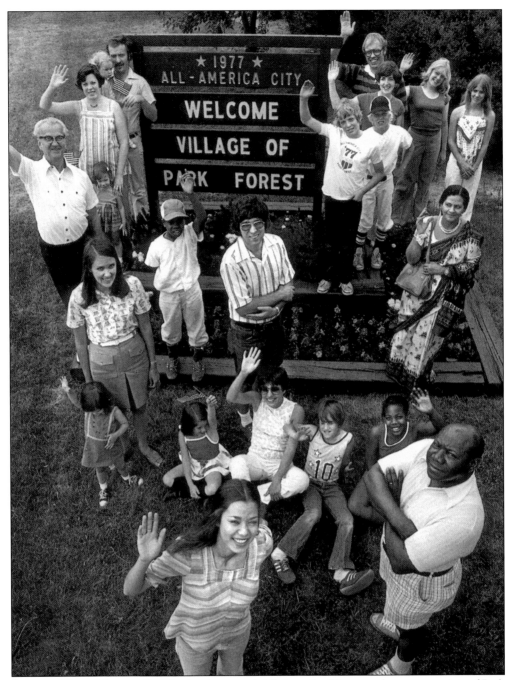

As part of the celebration for winning its second All-America City award, a cross-section of Park Forest residents gather at a sign commemorating the award. The village was cited for establishing a drop-in center for youth, working to develop a fair housing program in the area, and for raising more than $177,000 by volunteers to help furnish newly-constructed Freedom Hall.

Four

CHALLENGES AND RESPONSE

By the 1970s, the once-flourishing Plaza was in trouble. Newer shopping centers had drained customers and made the outdoor mall obsolete. After a number of ownership changes and an unsuccessful renovation to the The Centre in 1984, the village took control by purchasing the center and turning it into a new mixed downtown area. Park Forest also sought better housing for its growing senior citizen population, as well as taking a vital role in creating more recreational activities for all residents.

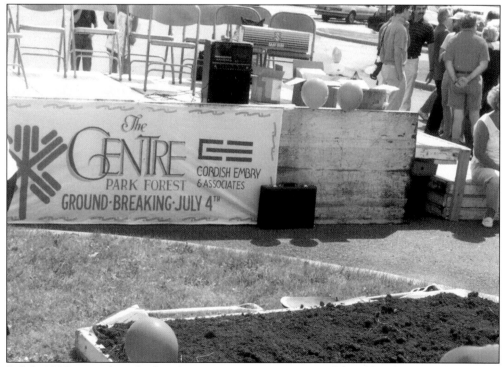

In July 1985, ground was broken for a massive reconstruction of the old Park Forest Plaza. It was to be called The Centre, and would offer new innovations in marketing, while keeping the basic look of the old Plaza.

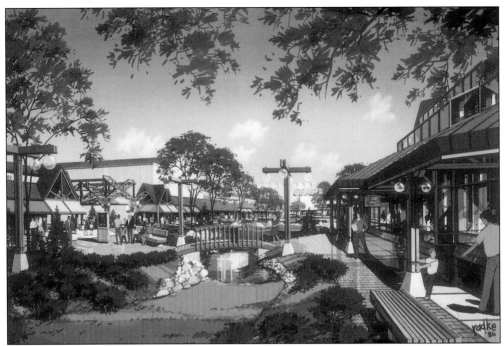
Village officials were shown an artist's conception of The Centre after complete renovation. The clock tower, once the center of the shopping center, was not part of the new plan.

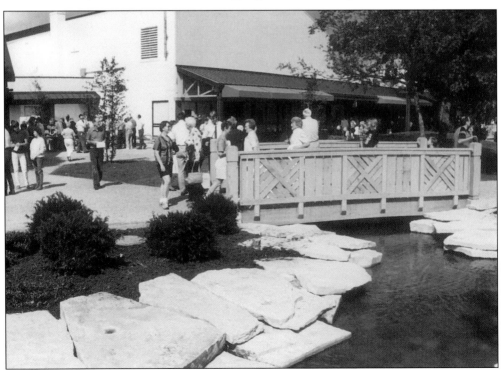
Opening ceremonies for The Centre drew a large crowd, but despite the changes, it failed to attract new business. (Photo by William H. Cramp.)

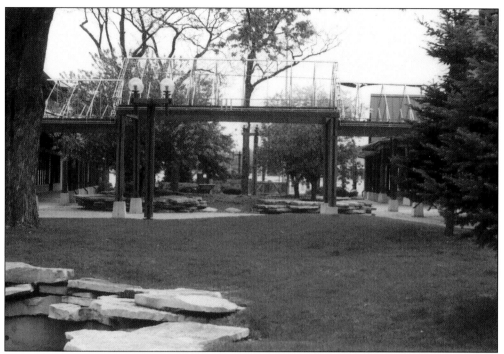

The Centre boasted a covered walkway in the center of the shopping area. Such cosmetic renovations did little to lure business into the area.

Soon the little stream under the bridge in the center of The Centre ran dry. Some citizens thought this was symbolic of a failed attempt to renew the area.

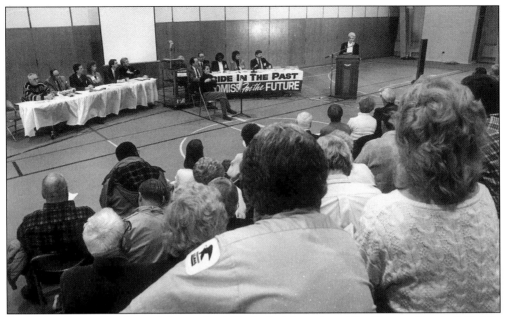

By 1991, village officials needed to make difficult decisions about The Centre. Marshall Field's, once an anchor tenant, was gone. In November 1991, this town meeting held in Rich East High School, began to weigh the options available. Trustee Shirley Yingst is seen at the podium addressing the large audience.

Long-time residents Bo and Helen Lawrence (center), and then-Trustee and later Village President F. Patrick Kelly (right) listen to plans for the downtown area presented at that town meeting.

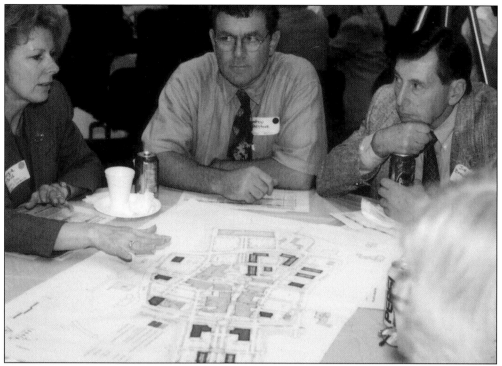

Village Trustee Andy Gladstone (center) and James Brownlee (right) of the village's Plan Commission discuss various proposals for the redevelopment of the old business district.

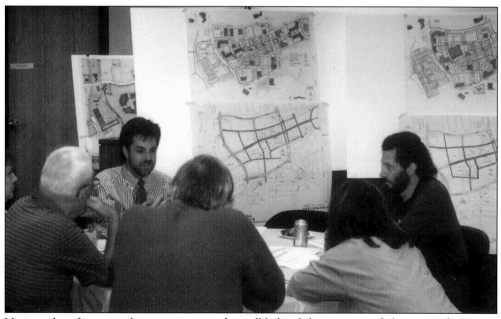

Various plans for a new downtown are on the wall behind this meeting of planners and citizens.

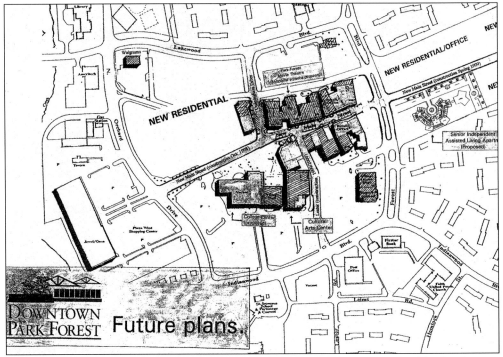

This was the basic plan for a "new" downtown that won the approval of both planners and village officials.

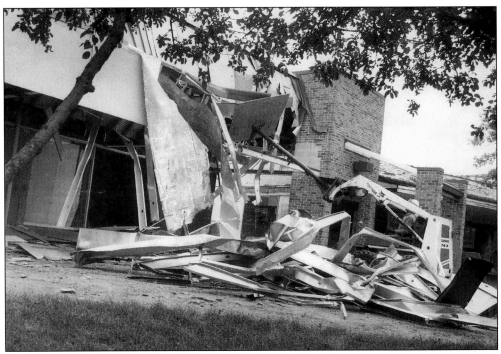

In 1995 Park Forest purchased The Centre and began demolition in an effort to pave the way for a new downtown.

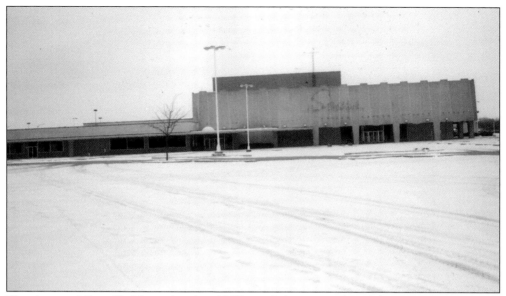

The shuttered Sears Building, closed in 1995, is a forlorn reminder of things past.

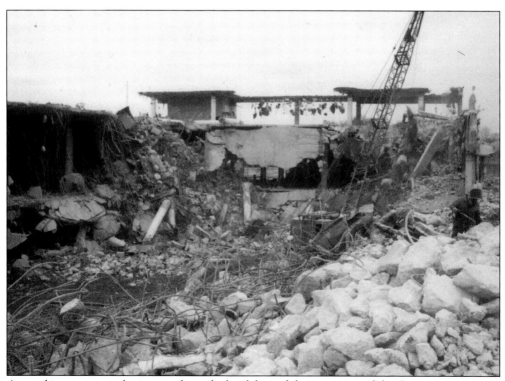

A wrecking crane works its way through the debris of the remnants of the Sears store.

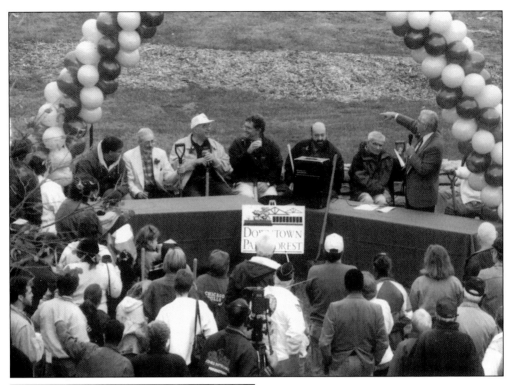

Downtown Park Forest begins to rise from the dust of demolition at this ceremony held in the area where the clock tower once stood. Village President F. Patrick Kelly (standing) explains to the audience how the area will change. Others seated are, from left, Trustees Matt Guritz, Jon Steinmetz, Ken Kramer, Andy Gladstone, Bill Patterson, and former Village President Robert Dinerstein.

Citizens gathered at the dedication of the Downtown area. Some came with shovels and volunteered to help clear the area.

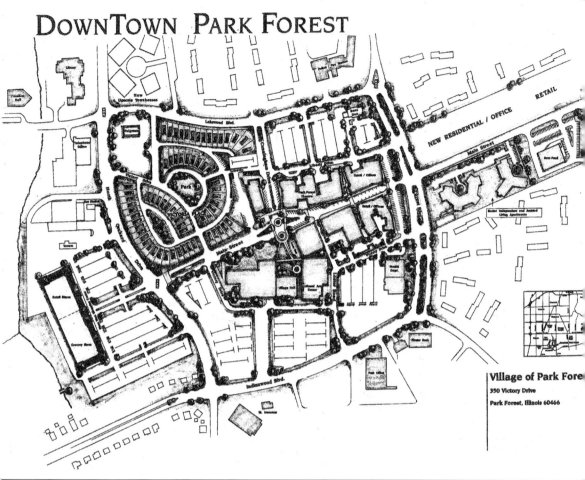

Downtown slowly emerged and changed the shape of the center of Park Forest. This is a later version of the plan, and includes new stores and housing built in the last three years.

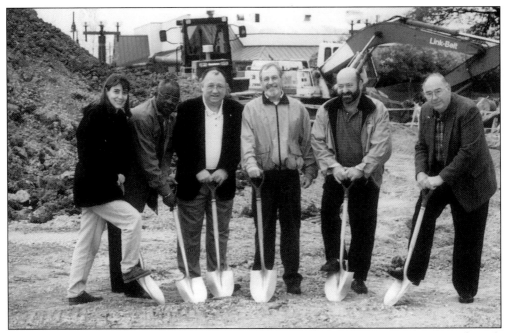

Elected officials pose at a groundbreaking ceremony for a portion of Main Street running through the Downtown area. They are, from left, Trustees Rita Guritz and Robert Furnace, Village President John A. Ostenburg, and Trustees Jon Steinmetz, Bill Patterson, and Ken Kramer.

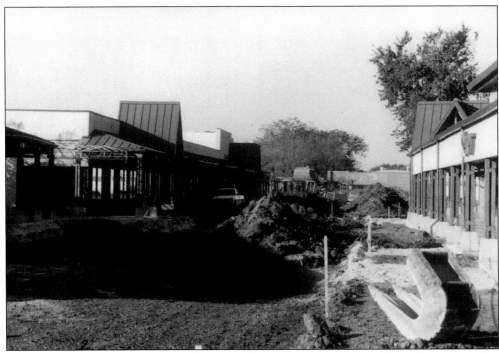

While much of the exteriors of buildings in The Centre were renovated, work continued on cutting a Main Street through the heart of the new shopping area.

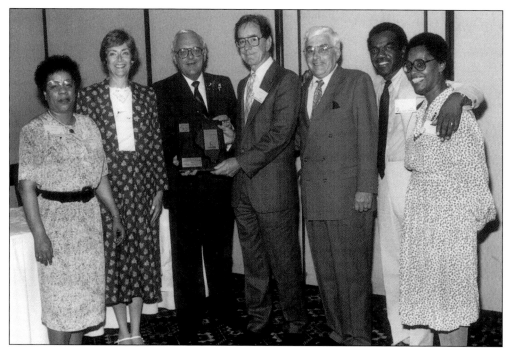

Village President Jerry Mathews receives the Illinois Governors Hometown Award for 1988 from then-Lt. Governor George Ryan. Pictured are, from left, Community Relations Director Barbara Moore, Jane Steinmetz, Ryan, Mathews, State Senator Aldo DeAngelis, and Roy and Bonita Dillard.

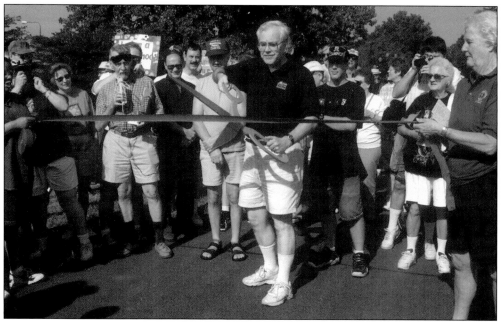

Village President F. Patrick Kelly uses a symbolic set of shears to open a paved stretch of the Old Plank Trail Bicycle Path, stretching from Park Forest west to Frankfort. The path, built over an abandoned railroad track, is currently 19 miles long and goes west to Joliet.

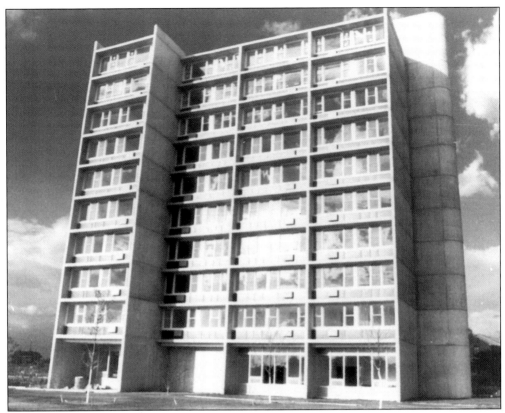

As the village aged, so did its residents. Juniper Towers, built in the 1970s, helped answer the growing need for senior citizen housing. A similar development, Garden House, was later added to the Park Forest landscape.

Five

CELEBRATIONS AND ANNIVERSARIES

Anniversary celebrations were always important to Park Forest. But its 50th birthday was special. It took more than one year of planning to account for all the activities during its Golden Anniversary in 1999. A volunteer committee made plans for numerous small celebrations throughout the year, culminating with a "Welcome Back" Fourth of July weekend for thousands of former residents who returned for a massive observance. A key to the festivities was the dedication of the Memory Lane walkway, with inscribed bricks honoring those whom Park Forest has touched.

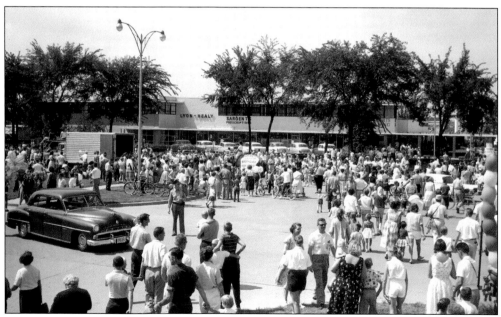

A large crowd gathers in the Plaza at an outdoor celebration of Park Forest's 10th anniversary in 1959. The large anniversary sign can be seen in the background.

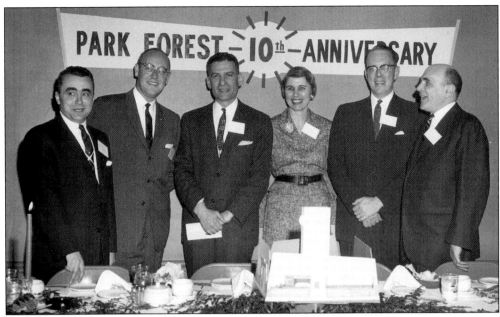

Former village officials pose for pictures at the 10th Anniversary Dinner. From left, Henry X. Dietch, Douglas Stevenson, then-Village President Robert Dinerstein, Ruth Skaggs, Health Department Director C. Duane Cory, and Claude Wells.

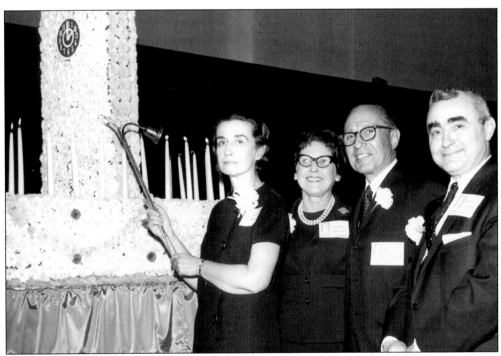

Mrs. Margaret O'Harrow, widow of first Village President Dennis O'Harrow, helps light the 20 candles atop a large cake at Park Forest's 20th anniversary celebration in 1969. Next to her is Leona DeLue, who—along with her husband Ross DeLue—were among Park Forest's first residents, Philip Klutznick, and former Village President Henry X. Dietch.

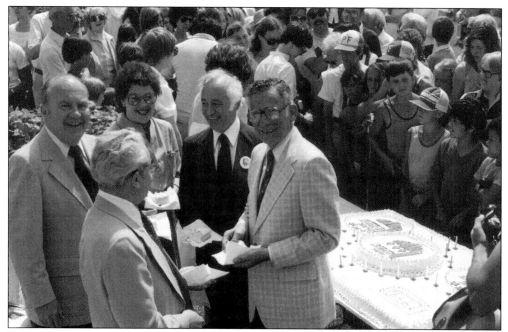

Past and present Park Forest officials celebrate the village's 30th anniversary in an outdoor setting in 1979. From left, former Presidents Bernard G. Cunningham and Henry X. Dietch (back to camera), Village Clerk Shirley Sullivan, then-Village President Mayer Singerman, and former President Robert Dinerstein.

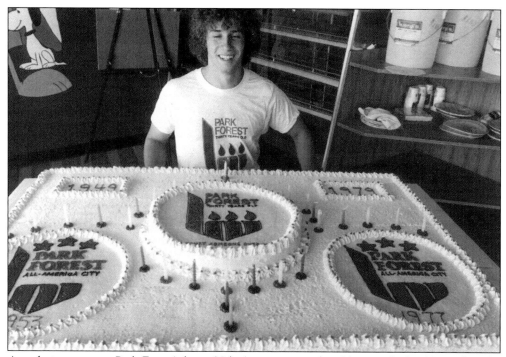

An admirer gazes at Park Forest's large 30th Anniversary cake. Along with the 30 candles, the cake highlights the village's two All-America City awards, conferred in 1953 and again in 1977.

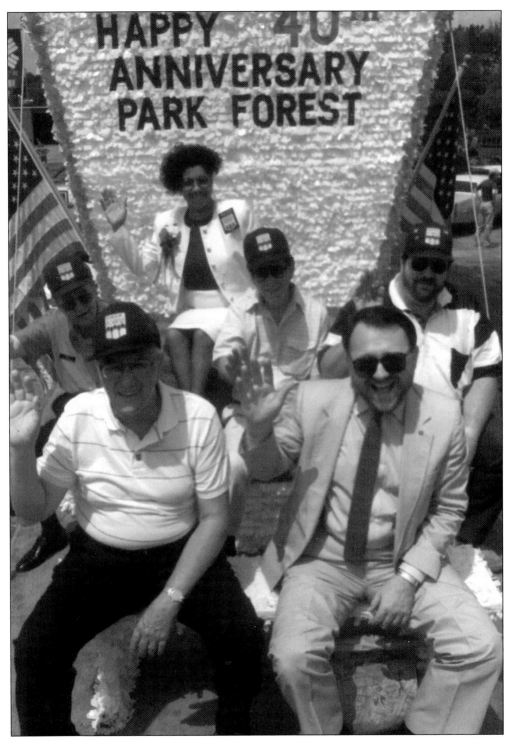
Village officials ride a float during the Independence Day parade in 1989, during the village's 40th anniversary celebration. They are, from left, Trustees Pat Duffy, J. Ron McLeod, and Viola Baecher, Village President Jerry Mathews, and Trustees John A. Ostenburg and Archie Long.

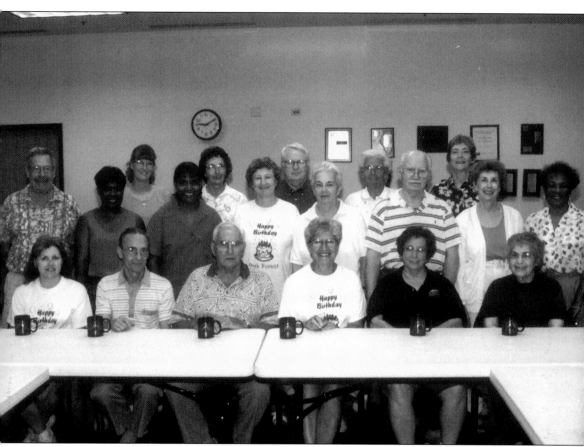

Members of the village's 50th Anniversary Committee worked for more than one year to prepare and plan for Park Forest's yearlong Golden Anniversary birthday party. They are, seated, from left, Jane Nicoll, Carl Reed, J. Ron McLeod, Committee Chairperson Therese Goodrich, Judy Lohr, and Beverly Myrow. Standing, from left, John Goodrich, Gail Graham, Amy Wlos, Yvonne Robinson, Helen Lawrence, Terry Townsend, Bob Smart, Rosemary Ryan, Eleanor Burns, Bo Lawrence, Jane Steinmetz, Suzanne Brown, and Myrtle Martin.

The hundreds who attended Park Forest's 50th anniversary of its incorporation consumed dozens of homemade birthday cakes. The event, held at Rich East High School, included speeches and music by village residents. This reception followed the formal presentation.

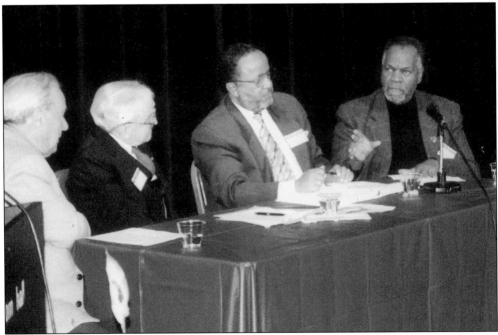
One of the highlights of Park Forest's 50th Anniversary was a program devoted to the village's African-American community during Black History Month. On the Freedom Hall stage, are, from left, Anthony Scariano, Henry X. Dietch, former Village President Ron Bean, and Leonard Robinson in a discussion of the village's successful efforts at integration.

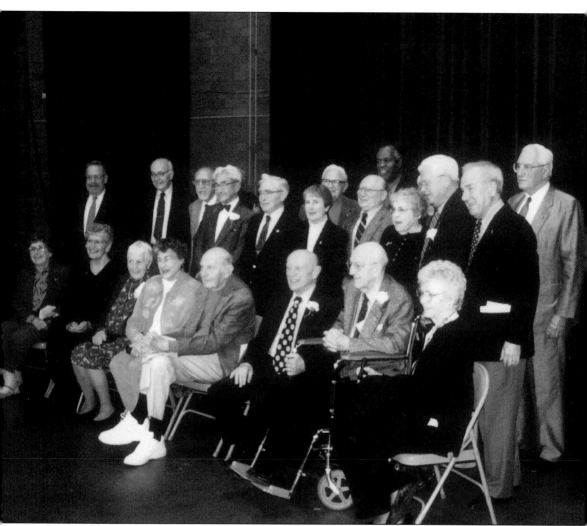

The Park Forest Hall of Fame members gather for a group picture during induction ceremonies in 1999. They are, seated, from left, Leona DeLue, Therese Goodrich, Wilma Brenne, Gertrude Gold, Ross DeLue, Ray Janota, John North, and Ruth Skaggs. Standing, from left, John Goodrich, Dewey Helmick, Lester Skaggs, George Maeyama, Henry X. Dietch, Rose Carol Brown, Manny Racher, Harold Brown, Leonard Robinson, Beverly Myrow, Alice Racher (partially hidden), Sam Walker, Anthony Scariano, and J. Ron McLeod.

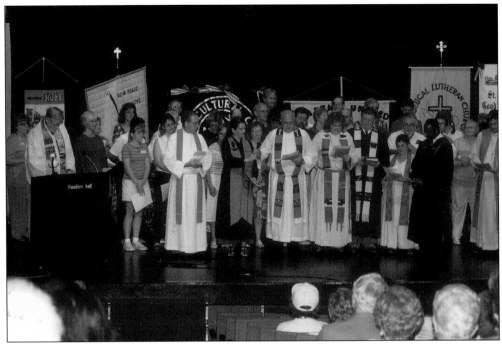

Members of the clergy and others representing all religious faiths in Park Forest gathered for a special celebration over the July 4 weekend as part of the 50th Anniversary. The event symbolized the village's diversity, spirit of sharing, and community.

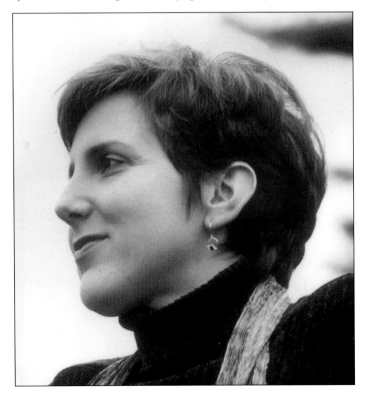

World-renowned opera and concert singer Dawn Upshaw returned to the community she grew up in for a gala concert that ended the 50th anniversary.

"That's where I lived" may have been the message by one person pointing to a large aerial map of the village. The map was on display in the Downtown Management office during Park Forest's 50th Anniversary.

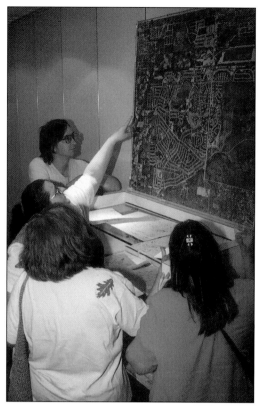

Film writer-director Jerome Courshon, a former resident, answers questions after the Midwest Premiere of his movie *God, Sex & Apple Pie* was shown in Park Forest as part of the 50th Anniversary celebration.

Therese Goodrich, chairperson of the 50th Anniversary committee, cuts the gold ribbons, formally opening Park Forest's Memory Lane walkway paved with etched bricks purchased by and for residents of the village.

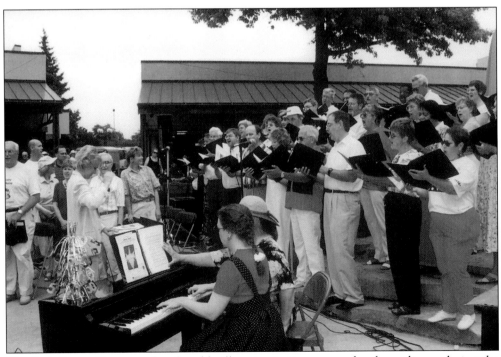

The Park Forest Singers, a decades-old village institution, serenades the audience during the dedication of Memory Lane.

Where's My Brick? During ceremonies dedicating the walkway, residents and visitors searched for a particular brick, and were often surprised to see names of their friends.

Members of the Hetke family—all raised in Park Forest—return pose with their street painting during a "Paint the Town" celebration where residents decorated portions of Main Street with messages of their choice. They are, from left, John Thornburn and his wife Lynn Hetke Thornburn of Phoenix, AZ, and Susan and Richard Hetke of Danville, CA. Another son, Bill Hetke, kneels in back. The Hetke family has lived in Park Forest since 1952. (Photo courtesy of the Hetke family.)

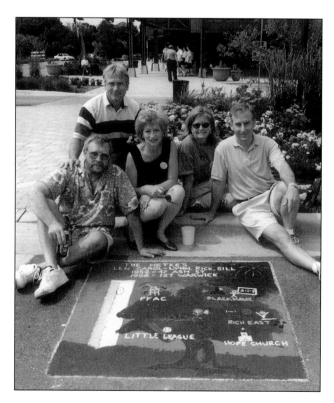

Volunteers gather behind the table in Freedom Hall during Park Forest's 50th Anniversary celebration during the July 4, 1999 weekend. Members are, from left, Julia Randolph, Amy Wlos, Virginia Hart, Patsy Graves, and Vangie Derrig.

Freedom Hall was the center of activities during the July 4 weekend. On the right is a table selling gifts, shirts, mugs, and hats commemorating Park Forest's 50th anniversary. Next to it was a board where former residents returning for the celebration could leave messages for others.

Ross and Leona DeLue, among the first permanent Park Forest residents, were the Grand Marshals of the 50th Anniversary parade. The DeLues lived in Park Forest for more than 50 years.

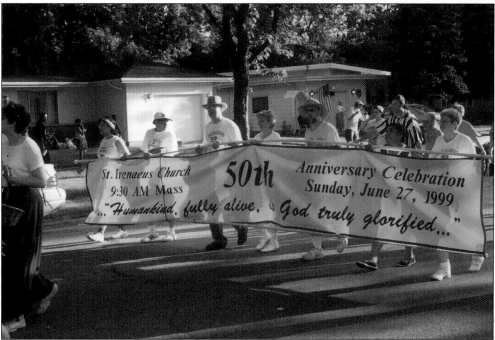

Members of St. Irenaeus Catholic Church, which also celebrated its 50th birthday in 1999, march in the village's massive 50th anniversary celebration on July 4, 1999.

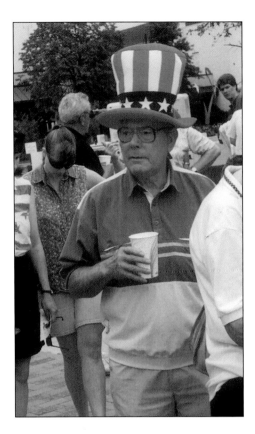

Park Forest resident John Bohn celebrates the 50th anniversary in his oversized Uncle Sam hat.

The bust of Park Forest founder Nathan Manilow, located in Freedom Hall, sports a new hat during the anniversary celebration.

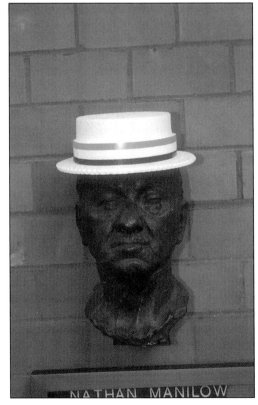

Six

THEN AND NOW

Through the years Park Forest has moved, adopted, erased, eliminated, and renovated everything from streets, homes, churches, and plans. Here are a few examples of what Park Forest was like some 50 years ago, and what changes have taken place.

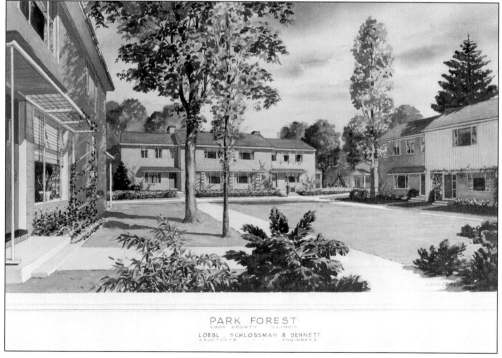

Town houses in court-like settings were the goal for the developers of Park Forest. This is a vision of what the apartments would be like. (Drawing courtesy of Loebl, Schlossman, & Hackl.)

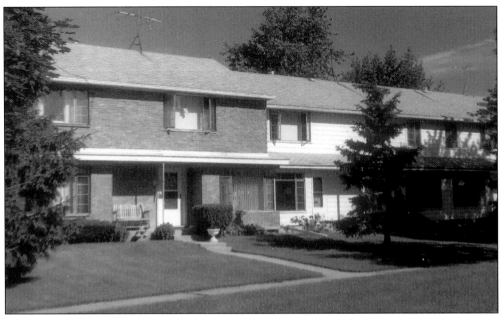

A typical town house unit, built more than 50 years ago, and still in use in Park Forest today.

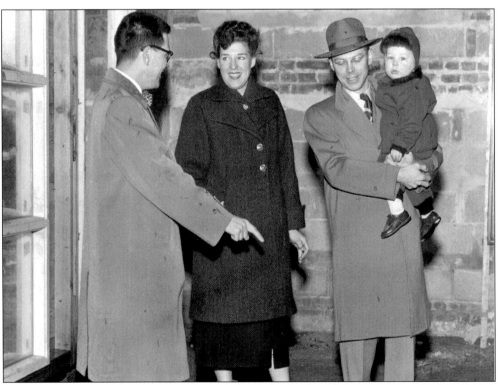

In 1952, Lester B. Palmquist, his wife, and their 13-month old son Wayne were the 1,000th family to buy a single-family home in Park Forest and are congratulated by John H. Martin (left), who became the 1,000th renter two and one-half years before that. The Palmquists purchased a still-unfinished home at 351 Neola Street.

Pictured is the Palmquist house at 351 Neola Street. The family can be seen at the left.

The Neola Street house as it looks today, after numerous renovations and additions.

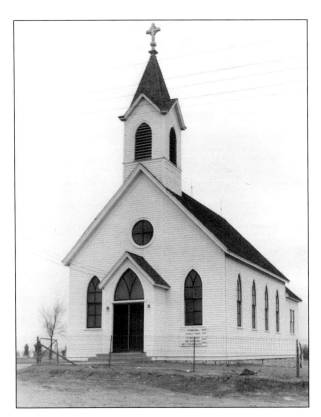

Old St. Ann's Parish church was located near the current intersection of Sauk Trail and Westwood Drive, now the site of the Park Forest Tennis and Health Club.

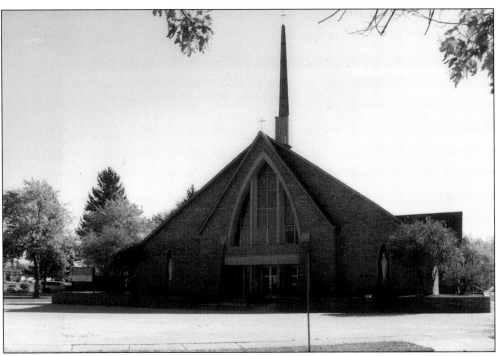

St. Irenaeus Catholic Church, at the intersection of Indianwood Boulevard and Orchard Drive.

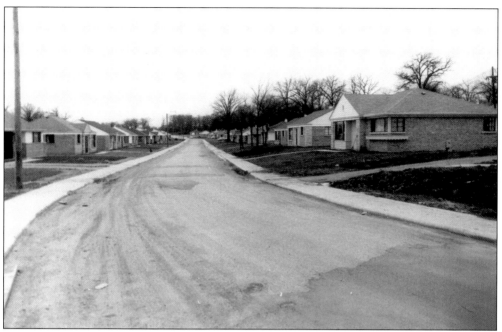
In 1951, new homes on Oswego Street were being built at a rapid pace.

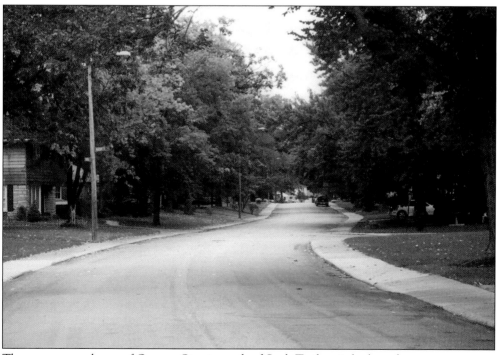
The same general area of Oswego Street, south of Sauk Trail, as it looks today.

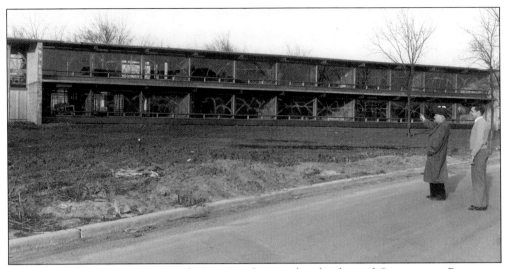

Gerson Engelmann, its pastor, and Hugo Leinberger, the chaplain of Cooperating Protestant Denominations, are seen at the far right viewing progress during construction of Faith United Protestant Church.

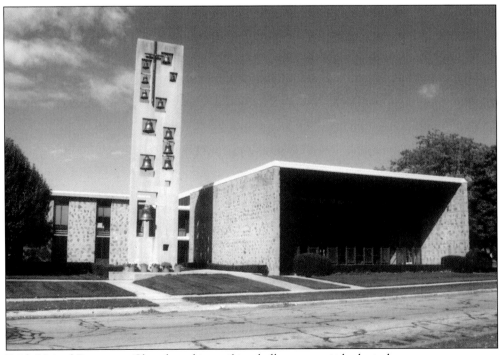

Faith United Protestant Church and its striking bell tower, as it looks today.

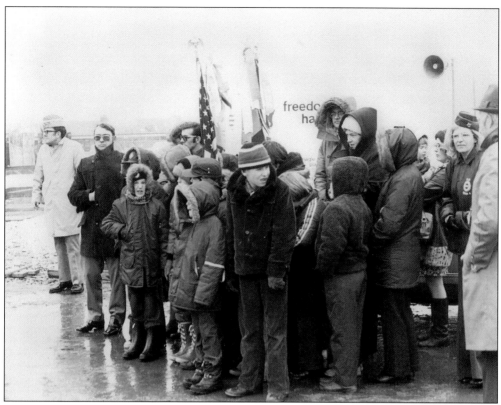

On a bitterly cold day in 1975, residents of all ages turned out for the laying of the cornerstone of what was to be Freedom Hall, the village's new two-story community center located next to the library on Lakewood Boulevard.

Today, Freedom Hall is used for meetings, exhibitions, and both theater and concert productions.

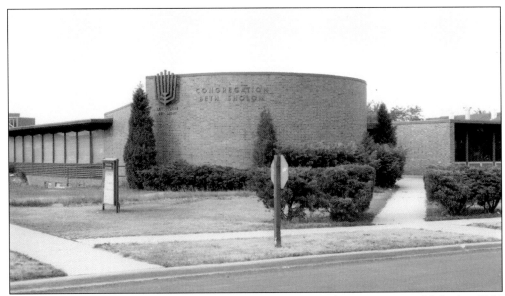

Congregation Beth Sholom, the oldest Jewish synagogue in Park Forest, was established in 1951 with the help of Philip Klutznick. Prior to the building of the temple, services were held in the Holiday Theatre. Services were held in this building until May 1998, when Beth Sholom merged with Temple B'nai Yehuda in Homewood.

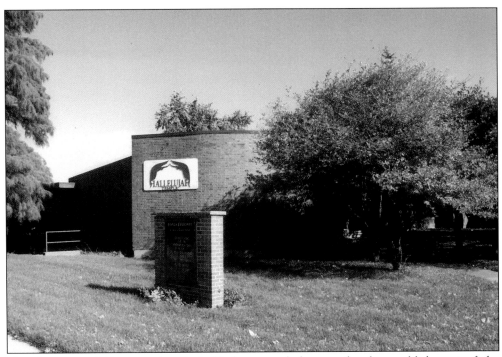

The departure of Congregation Beth Sholom paved the way for the establishment of the Hallelujah Temple Ministries.

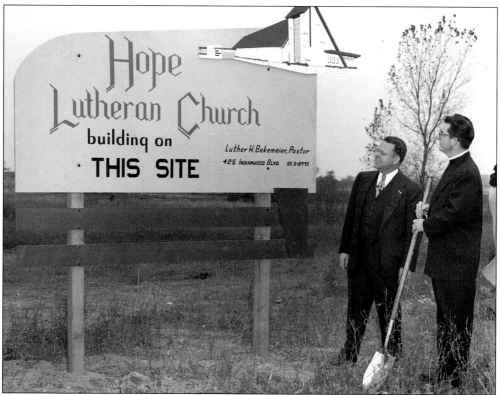

Carroll Sweet Jr. and the Rev. Luther Berkmeier are at the groundbreaking for Hope Lutheran Church in 1953.

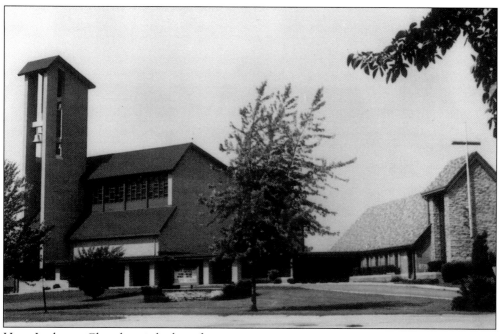

Hope Lutheran Church as it looks today.

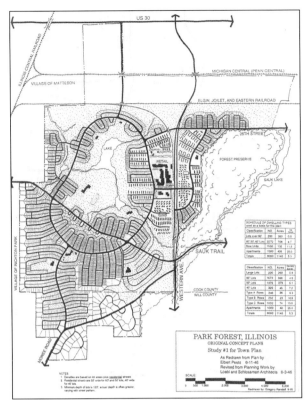

City planner Elbert Peet drew the original plan for Park Forest in June 1946. Most elements of the plan were carried out in construction of the community, including a commercial center, apartments on both sides of Western Avenue and the ringing of the large Central Park with homes. (Drawing courtesy of Loebl, Schlossman, & Hackl.)

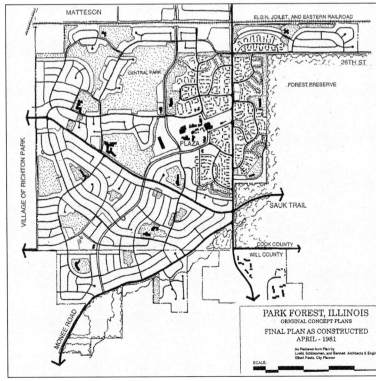

A "final" map of Park Forest, with current boundaries, created in 1981. (Drawing courtesy of Loebl, Schlossman, & Hackl.)

Seven

CAPTURING THE SPIRIT

Park Forest residents have maintained their interest in the community, and the village has responded. From the 25-year-old Scenic 10-Mile Race to the nearly 50-year-old Art Fair, from the Health Department to senior citizen housing, and from its Wetlands Project to its golf course, Park Forest still plays a vital role in the lives of its citizens. It's motto "Capture the Spirit" still resonates in the vitality of its citizenry.

Park Forest reached the finals of the All-America City competition for the fourth time, in the Year 2000. The delegation representing the community, from left, Mel Muchnik, Myrtle Martin, Jerry Shnay, Mignon McDade, Suzanne Brown, Village President John A. Ostenburg, Village Manager Janet Muchnik (next to Allstate Insurance Co. President Edward M. Liddy), Penny Shnay, Trustees Robert Furnace and Bonita Dillard, and Roy Dillard.

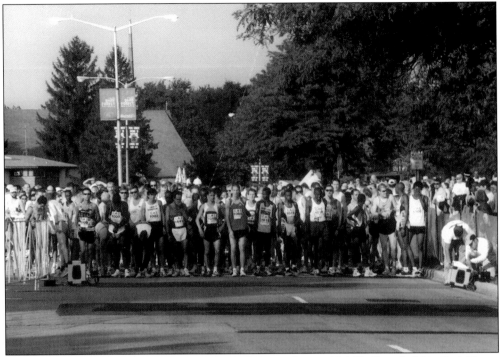

More than 2,000 line up for the start of the Park Forest Scenic 10-Mile Run, held in Park Forest each Labor Day since 1977. The race, named the best distance race in the Chicago area for the last eight years by the Chicago Area Running Association, winds through miles of forest preserves and streets where an international field of competitors are greeted by musicians and performers.

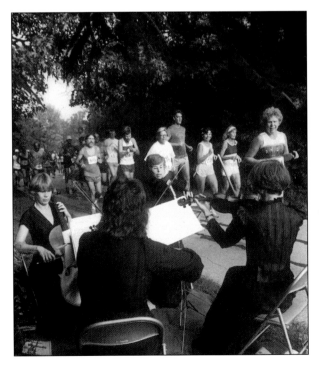

One of the most distinctive aspects of the Scenic 10 is the string quartet, which greets runners as they enter a 4-mile stretch of the race through the Cook County Forest Preserves. The quartet has been an annual feature of the race since its inception.

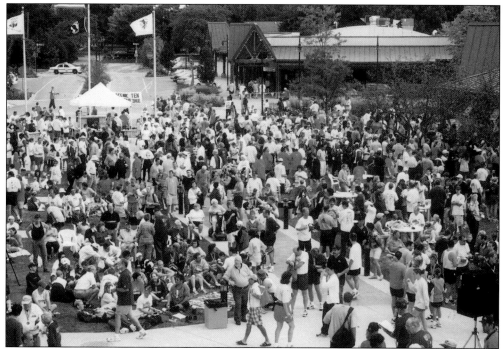

Thousands throng the Village Green for the awards ceremony after the Scenic 10. Attendance is bolstered by youths who compete in age-group races along Main Street.

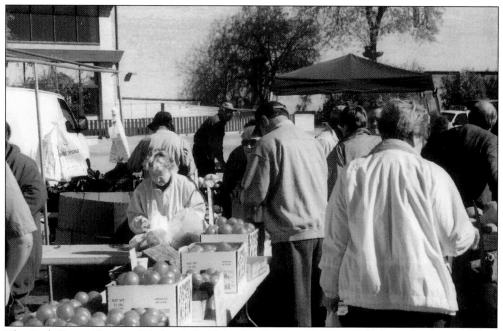

The Park Forest Farmers Market is held in the Downtown area each Saturday from the first week of May through the last week of October. Here, consumers shop for produce from area farmers and producers. Special sales are conducted by local civic clubs and houses of worship in the Market.

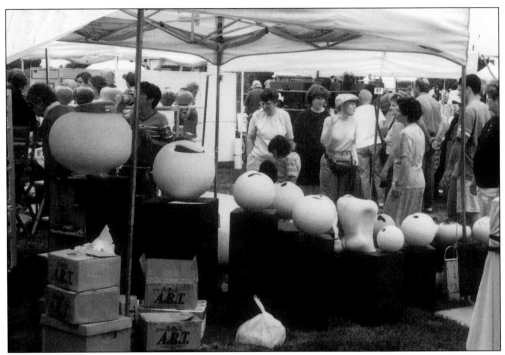

A display of pottery draws the attention of visitors to the Park Forest Art Fair, a two-day juried exhibition held each September on the Village Green.

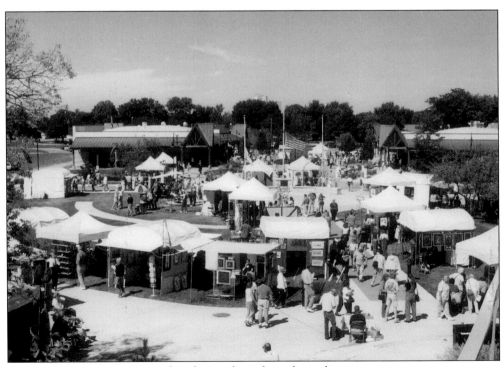

The Art Fair attracts artists and craftsmen from throughout the nation.

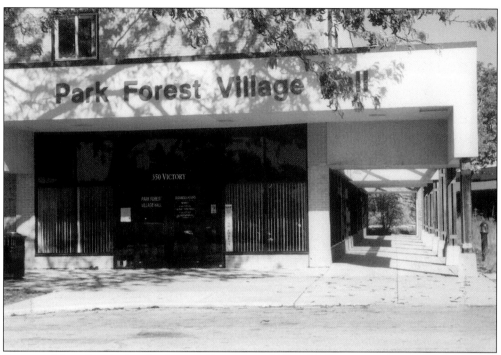

As part of the village's plan for the new Downtown, Village Hall was moved in 1995 into a larger two-story building at 350 Victory Drive, which formerly housed a women's clothing store.

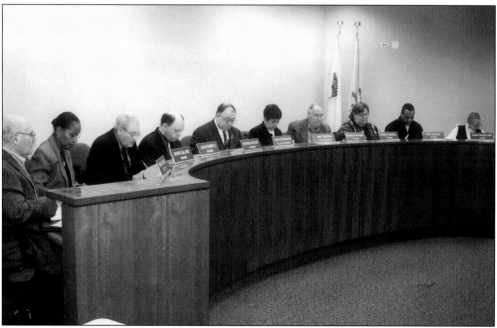

The 2001 Board of Trustees in meeting, are, from left, Trustees Harold Brown, Bonita Dillard, and Jon Steinmetz, Village Attorney Matt Delort, Village President John A. Ostenburg, Village Manager Janet Muchnik, Trustees Ken Kramer, Steve Campbell, and Ron Wilson, and Village Clerk Joan Frontczak.

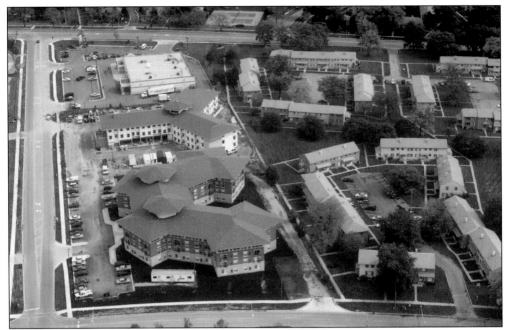

The Victory Center for Independent Living, a 95-unit apartment building for senior citizens, was constructed on the site of the former Sears building and opened its doors in 2001. At the same time, ground was broken next to this building for an assisted living facility. At the top of the photo, at the intersection of Western Avenue and Main Street is the recently opened Osco Drug Store.

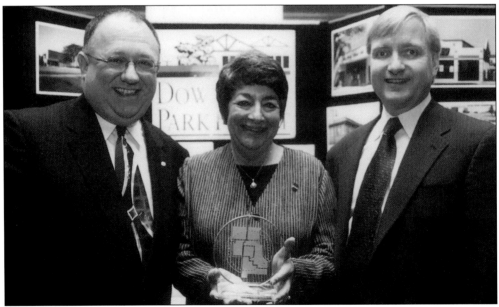

The prestigious Burnham Award for the year 2000 was presented to Park Forest for its innovative Downtown plan. From left, Village President John A. Ostenburg, Village Manager Janet Muchnik, and Robert Clough of the Burnham Awards committee. Clough is also president of Loebl, Schlossman, & Hackl, the original village architects.

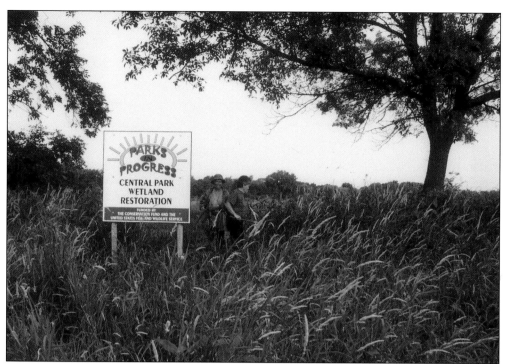

One of Park Forest's ongoing projects is the establishment of a Wetlands Restoration project in part of its large Central Park. Here, citizen volunteers trim some of the new growth. These volunteers perform much of the work in establishing new plants into the area.

As part of its recreational plans, the Park Forest Recreation and Parks Department operates an 18-hole golf course next to the village, as well as the Aqua Center and the Tennis and Health Club.

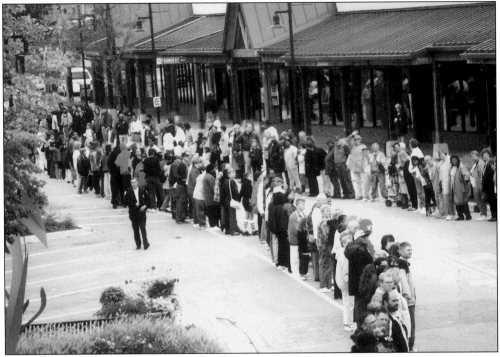
In 2000, Park Forest was the site of a Hands Across Southland celebration. As part of the program, a large handholding chain was staged from one end of Main Street to the other, symbolizing the spirit of community throughout the south suburbs.

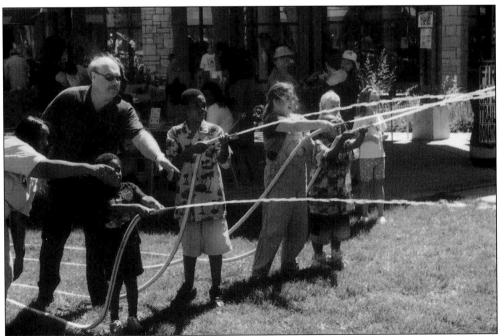
One of Park Forest's newest celebrations is the yearly Youth Day event held on the Village Green each Labor Day weekend. Here youthful firefighters learn how to handle a hose.

Thorn Creek Nature Center, located just off Monee Road, operates around the year, offering programs for both adults and children.

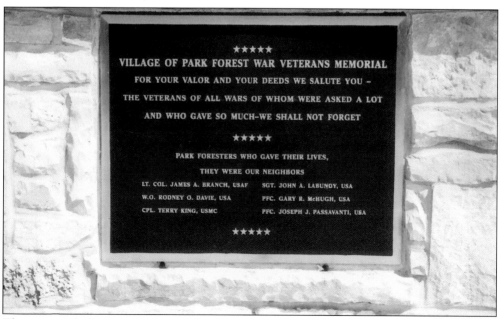

The memorial plaque at the base of the three flagpoles on Village Green is dedicated to the six Park Forest servicemen who died serving their country. All were killed during the Vietnam War.

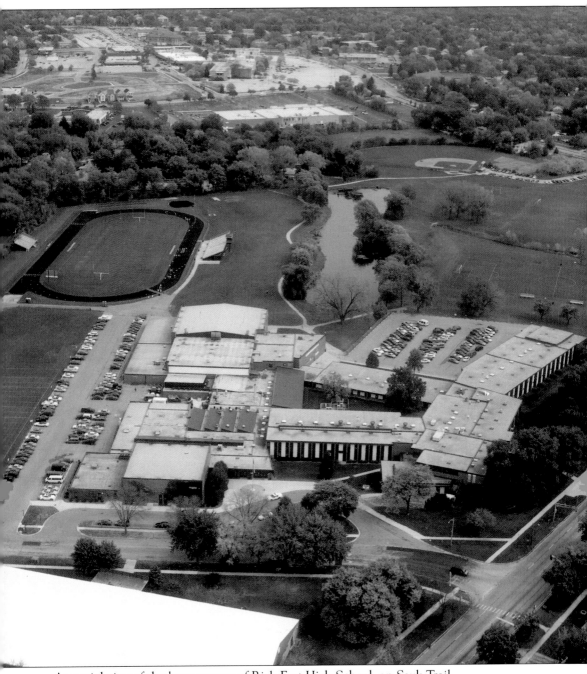
An aerial view of the large campus of Rich East High School, on Sauk Trail.

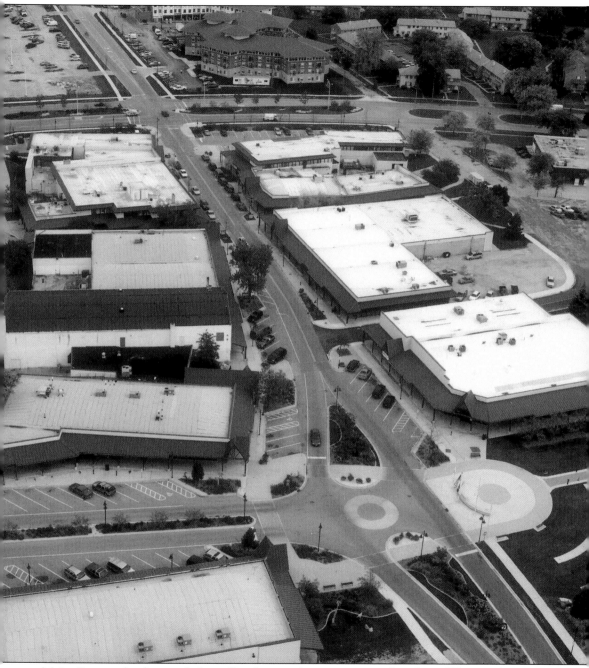
Main Street, the heart of the village's new downtown, stretches from Western Avenue to Orchard Drive.

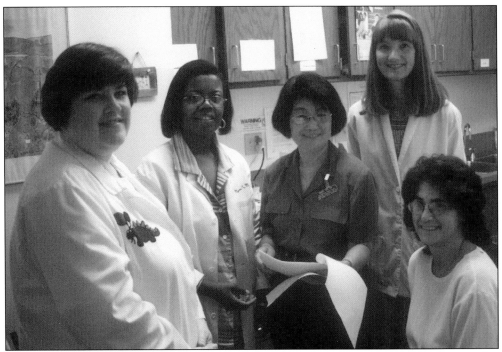

The Park Forest Health Department has a full range of services available for residents and is staffed by trained practitioners, from left, Catherine Cavitt, Margo Brown, Aimee Wei, Patricia Austermuhle, and Kathy McBride.

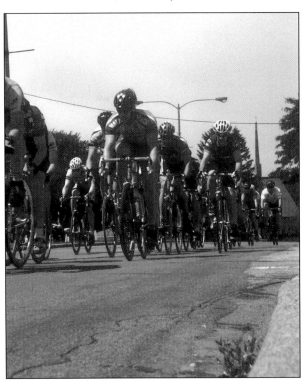

Among the newer events in Park Forest are the professional and amateur bicycle races held each May in the downtown area.

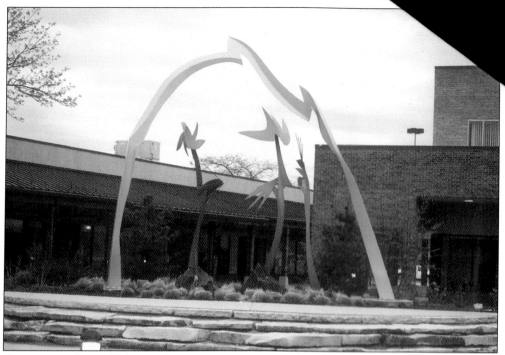
The stage in front of Memory Lane contains an original sculpture and is the scene of most of the events that take place in the Village Green each year.

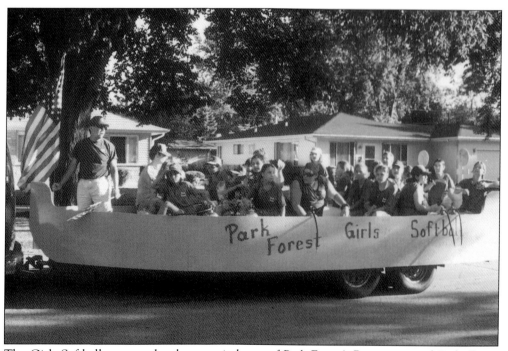
The Girls Softball program has been a vital part of Park Forest's Recreation and Parks Dept. program for decades. Here a float honoring Girls Softball is seen during the 2000 Independence Day parade.

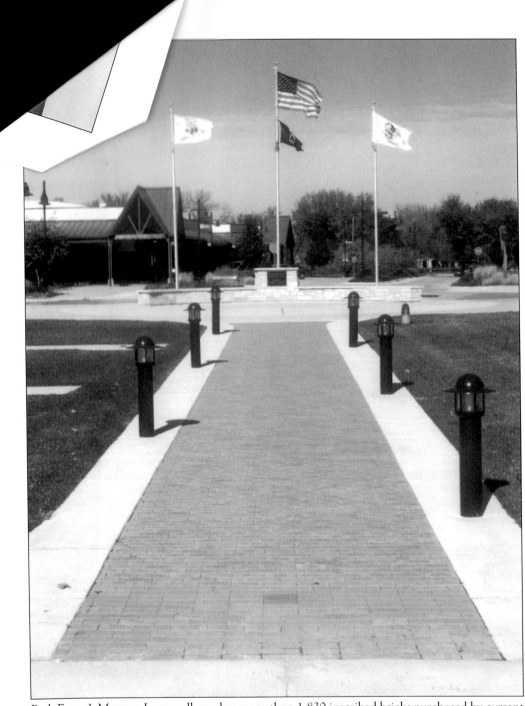

Park Forest's Memory Lane walkway has more than 1,830 inscribed bricks purchased by current and former residents of the village as well as friends of the community.